Inflation and the Performing Arts

SHERWOOD JAMES HALL, 1897–1968

The papers collected in this volume represent the proceedings of the conference, Inflation and the Performing Arts, held on the campus of the University of Nevada, Las Vegas in the Summer of 1981. The conference was made possible by the generous endowment of Sherwood James Hall, a public-spirited resident of Las Vegas, who wanted to support educational efforts to enhance community understanding of the principles of economics.

Inflation
and the
Performing Arts

Hilda Baumol *and* **William J. Baumol**
Editors

New York University Press
New York *and* London
1984

Library of Congress Cataloging in Publication Data
Main entry under title:

Inflation and the performing arts.

Papers presented at the conference held on the campus
of University of Nevada at Las Vegas on Aug. 6 and 7, 1981.
1. Performing arts—United States—Finance—Congresses.
2. Inflation (Finance)—United States—Congresses.
I. Baumol, Hilda. II. Baumol, William J.
PN2293.E35I53 1984 338.4'37902'0973 84-3351
ISBN 0-8147-1044-1 (alk. paper)

Clothbound editions of New York University Press books are
Smyth-sewn and printed on permanent and durable acid-free paper.

Contents

Preface

The chapters collected in this volume constitute the written record of the conference on Inflation and the Performing Arts, held on the campus of the University of Nevada at Las Vegas on August 6 and 7, 1981.

The conference itself was to a very large extent the production of three individuals. The idea for a colloquium on the economics of the performing arts to be held on the campus of the University of Nevada originated with William T. White, Professor of Economics and Chairman of the Department of Economics at this university. White's inspiration doubtless stemmed from his conviction that a broad community could benefit from a demonstration of how the discipline of economics could be employed to glean useful insights into the production and distribution of the various arts encompassed within the performing arts industry. It was all the more appropriate that this demonstration take place in Las Vegas, where the performing arts are so conspicuous a part of the local resort industry. Convinced of the worth of his idea, White then managed to engage the services of William J. Baumol and Hilda Baumol, by any measure leading scholars in economics and the arts, to help shape the meeting. And what a help they were! They gave the symposium its title, Inflation and the Performing

Arts, and authored the program for the two-day event; in addition, they lined up nearly all the conference speakers, who turned out to be a spicy mixture of professional economists, performing arts administrators, and arts critics; and they made their own substantial contribution to the meeting in their papers, which appear in this volume. Furthermore, after the meetings the Baumols performed the laborious task of editing the conference manuscript and acquired the good services of the New York University Press to see to its publication. Beyond conceiving the conference and engaging the help of the Baumols to render substance to his idea, White arranged that the meeting be financed through the S. J. Hall Endowment Fund and contributed the appendix to this volume. Oh, yes, White did one other thing perhaps worthy of note. He held an altogether agreeable untenured associate professor hostage to ensure that the conference participants were provided with food and shelter during their stay in Las Vegas.

While White and the Baumols were indeed the principals in bringing the conference together and in producing this record of the meeting, there were of course others who contributed to the effort. Leonard E. Goodall, President of the University of Nevada at Las Vegas, encouraged the entire project from beginning to end. Furthermore, the S. J. Hall Endowment Committee—composed of George W. Hardbeck, Dean of the College of Business and Economics; Dale F. Nitzchke, Vice-President for Academic Affairs; Barbara Schick, Director of the Center for Economic Education; and White—all of the University of Nevada—provided generous financial support for the entire endeavor. Two additional Nevadans must be counted for their encouragement and support of the conference: Marjorie Barrick, the university's patron of scholarship, and Charles Vanda,

the Director of Concert Hall Programming at the university. Then, of course, the contributors of papers to the conference were uniformly generous of their time and thoughts. Too, there are always those who perform the multitude of clerical chores associated with an effort of this nature, and these largely uninspiring tasks were all too graciously accomplished by Mary Mateja and Cheryl Wood.

As a final prefatory note, I would simply propose a toast. Ambrose Bierce defined a fiddle as "An instrument to tickle human ears by friction of a horse's tail on the entrails of a cat." May the chapters of this volume serve to tickle your senses on the condition of the performing arts in times of inflation.

Lewis Karstensson
Conference Arrangements Chairman
University of Nevada, Las Vegas

Contributors

Hilda Baumol was executive director of the research project that underlay the publication of the Baumol-Bowen book on the performing arts. She and William Baumol have since conducted a number of studies on the economics of the arts, including the Black Report, which was instrumental in the establishment of the half-price ticket booth (TKTS) and the off-off Broadway voucher program of the Theatre Development Fund. She was a consultant with MATHEMATICA, Inc.

William J. Baumol is Professor of Economics at Princeton and New York universities. He received his Ph.D. from London University. He is author of a dozen books on economics and coauthor with William G. Bowen of *Performing Arts—The Economic Dilemma* (New York: The Twentieth Century Fund, 1966). He also teaches a course on wood sculpture at Princeton University.

Thomas F. Bradshaw is an economist with the Research Division of the National Endowment for the Arts. He received his undergraduate degree from the University of North Carolina at Chapel Hill, and his M.A. degree in economics at George Washington University. Prior to joining the Research Division, Mr. Bradshaw worked as a senior project analyst for Applied Management Sciences, a research and consulting firm located in Silver Spring, MD, and as an economist with the Bureau of Labor Statistics, Office of Current Employment Analysis. Mr.

Bradshaw's analyses of labor force statistics have appeared in the *Brookings Papers on Economic Activity* and the *Monthly Labor Review.*

Irving W. Cheskin is an economist who received his Ph.D. from the New School for Social Research. He is Director of Pension and Welfare Affairs of the League of New York Theatres and Producers, Inc., and, until recently, was its Executive Director. His field of specialization is the economics of labor, which he applied in many years of negotiation with the various unions related to the theater.

Joe Delaney is performing arts columnist for the *Las Vegas Sun*. He also is a commentator for radio station KDWN in Las Vegas. He has an encyclopedic knowledge of the hotels, casinos, and concert halls of Las Vegas, including the complex economics governing arrangements between performers (including superstars) and managements.

Harold Horowitz has been Director of Research of the National Endowment for the Arts since 1975. He holds a master's degree in architecture from the Massachusetts Institute of Technology and has conducted architectural research and held managerial positions in the Albert Farwell Bemis Foundation at MIT, the National Academy of Science, the National Science Foundation, and the Energy Research and Development Research Administration. He is himself involved in research on the economics of the arts, including topics such as the compensation of performers and international comparisons of data on finances of the arts.

Alan Peacock is one of the world's leading authorities on public finance, on which he has published extensively. He is Principal (President) of the University College of Buckingham, Fellow of the British Academy, and member of the Council of the London Philharmonic Orchestra. He was for many years Professor of Economics at the London School of Economics and then at the University of York. He and two coauthors have just completed a

major and somewhat controversial report for the Arts Council of Great Britain on inflation and the performing arts in that country.

Richard Reineccius is Director of the 99 seat Julian Theatre in San Francisco. He teaches courses in theater arts at San Francisco State University; was a founder and an officer of the widely admired Neighborhood Arts Program; and founded, with the help of the Theatre Development Fund, an organization providing services to the performing arts in the Bay Area. He is a charter board member and Vice-President of the California Theater Council and has served as a Commissioner on the San Francisco Arts Commission.

Russell Sheldon is Senior Economist at the Mellon Bank in Pittsburgh. His field of specialization is econometrics, and he has published papers in the *Survey of Current Business* and in several leading professional economics journals. He has prepared a special report on the effects of inflation for the American Symphony Orchestra League and has lectured on this topic to special audiences. He has studied the course of inflationary developments and their consequences for the Mellon Bank.

Hugh Southern is Deputy Chairman for Programs at the National Endowment for the Arts. Until 1981 and since its inception he was Executive Director of the Theatre Development Fund. Its programs include a preopening loan program for meritorious Broadway plays and a costume loan collection. Its Broadway half-price ticket booth (TKTS) and voucher program for the support of small arts organizations have both been replicated in other cities. He is a graduate of King's College, Cambridge, and has been associated with the Westport Country Playhouse, the Theater Guild, the Lincoln Center Repertory Theater, the National Repertory Theater, Expo '67, and the San Francisco Opera.

Michael Walsh is music critic for *Time* magazine. He is a graduate of the Eastman School of Music and former music critic of the *San Francisco Examiner* and the *Rochester* (N.Y.) *Democrat and Chronicle*. He is secretary of the Music Critics' Association

and, in 1980, received the ASCAP Deems Taylor Award for distinguished criticism.

Herbert Weissenstein is, and has been since 1979, Director of Development of Carnegie Hall. Much of his career has been in the field of management, in which he has run the gamut from personal management to several major symphony orchestras. He has played an important role in the successful reorganization of Carnegie Hall.

William T. White is Professor of Economics and Chairman of the Department of Economics, the University of Nevada at Las Vegas. He is the author of a number of monographs and papers and serves as consultant to industry and government. Academics is his second career after retiring from the U.S. Air Force.

I
ON LARGE- and SMALL-
BUDGET GROUPS

1

The Family of the Arts

Hilda Baumol and William J. Baumol

A SUCCESSFUL conference acquires a life of its own. It refuses to confine itself to the theme that its organizers sought to impose. Of course, it must deal with that theme to some degree, and it will provide some new insights on that subject. But the enthusiasm and knowledge of the participants have a way of leading them to break constricting bounds and to strike out in other directions.

In the case of this conference on Inflation and the Performing Arts, which we organized with the Department of Economics of the University of Nevada at Las Vegas, we made several decisions that virtually guaranteed this result. The number of academic persons who have written on the economics of the performing arts is fairly small, and they have been heard from in person and in print many times. There is also a tendency in this field for researchers like ourselves to keep our hands clean—to take published figures and manipulate them ingeniously, often using formidable mathematical techniques, to construct models, indexes, and so on, without ever setting foot in the business side of a box office.

3

However, while carrying out commissions for the Twentieth Century Fund, the Theatre Development Fund, the National Endowment for the Arts, and other organizations, we have also been forced to spend many hours grubbing for information in managers' and producers' offices and, in the process, have come to appreciate their particular kind of intuitive insight and wisdom.

For the Las Vegas Conference such considerations led us to decide to invite, not only people with an academic viewpoint, but also actual practitioners whom we have known or heard about in the hope that this would add flesh to the bare bones of available statistical materials. We must hasten to add that no criticism of these standard sources of information is implied. The laboriously gathered and intelligently presented annual reports of the American Symphony Orchestra League, the Theatre Communications Group, and so forth form the substance of our researches.

In addition to the influence on direction exerted by the dynamics of the conference itself, a major role was also, quite unexpectedly, played by its location. Las Vegas, of course, is a center of live performances, most of which, despite a flourishing classical music series, are very different from the typical presentations at, say, Carnegie Hall. But, in a variety of ways that will be described presently, the conference profited a great deal from its proximity to these performances.

1. On the Influences of Inflation

In this attempt to summarize the insights that emerge from this book, it is natural to begin with its preselected subject, the role of inflation. Significant light was shed upon

many facets of the subject before the conference came to an end.

The first and central question was whether inflation has made it more difficult for performing organizations to cover their expenses. This may appear to noneconomists to be a foolish question, but it is not. Economics teaches that rising prices need not mean that individuals or groups will find it increasingly difficult to keep up with their bills and to prevent erosion of their living standards. If workers in industry X have a wage contract with a built-in escalator clause that automatically brings adjustments in wage rates that make up for the rising cost of living, their families will experience no difficulty in keeping up with the rising prices of their purchases or in preventing a decline in their standard of living. The same is true of retired persons living on social security, whose payments have in recent years been adjusted liberally for changes in the price level. The fact is that inflation may or may not cut a consumer's purchasing power, depending upon whether the rate of inflation of his own income is greater or smaller than the rate of inflation of the prices of his purchases. Inflation involves everyone in a race between incomes and outgoes, and in this race, as in others, there will be winners and there will be losers.

In the case of inflation there is a special reason for this. When a product or a service is sold, all the revenue collected in exchange must be paid to someone—as wages to the workers who made it; as payment to the suppliers of raw materials; or, faute de mieux, as profit to the investor or the entrepreneur. This means that if the price of a product rises 10 percent with no decline in the quantity sold, then receipts from its sale must also go up 10 percent. Consequently, wages, payments to suppliers of other inputs, and payments to investors and management *must* also rise 10

percent *on the average.* Clearly, some of those groups may fall behind while others beat this norm. But it is arithmetically impossible for the incomes of all these groups to fall behind the movement in price.

Inflation undoubtedly has many undesirable consequences: it causes uncertainty, leads to erosion of product quality, inhibits a country's economic policy, causes losses in the purchasing power of particular groups, and brings about a general feeling of social malaise. But inflation does *not* make everyone poorer (although it may make everyone feel so).

Consequently, the central question relating to the arts, as for every other sector of our society, is whether they have been able to keep up; whether the inflation in its various sources of earned and unearned income has or has not kept abreast of the inflation in its costs.

The surprising answer, which seems to be confirmed from every quarter, is that at least up to 1981 the arts had, indeed, managed to keep up. For some arts forms and many groups it was undoubtedly far from easy. Yet, somehow, incomes did manage to keep up with costs.[1]

This bare fact raises more questions than it answers. How was this result achieved, and was it quite as pure a blessing as it appears? How much of the rise in revenues was obtained from increased earnings at the box office, and how much was obtained from private philanthropy and public support? Were cost increases restrained by rising efficiency, by lags in the wages of the performing artists, or by economies of other types whose innate desirability can well be questioned?

The fact that the incomes of the performing arts organizations have so far managed to keep up with expenditures, which is surprising in itself, becomes even more remark-

able in light of two noteworthy impediments. The first is the fact that ticket prices seem generally to have lagged substantially behind the economy's rate of inflation. As will emerge in the chapters that follow, this was true of the commercial theaters until very recently and of the larger orchestras (i.e., those whose total budgets are relatively large), and there is no reason to doubt that this pattern holds for other major sectors of the arts.

Along with lagging ticket prices, the solvency of the organizations that provide live artistic performance has been threatened by a second phenomenon that has been referred to as their "cost disease." Live performance must compete in an economic world that, at least until the end of the 1970s, had become habituated to rising productivity to which the arts are largely denied access. Year after year, innovations that have progressed from steam engines to assembly lines to automation to robotics have increased the productivity of the work force and thereby partly offset the effects of rising wages upon the prices of manufactured goods. For *live* performance such cost-offsetting productivity increases are far more difficult to attain. The very nature of the product dictates the amount of labor time required to perform it. The Baumol-Bowen Twentieth Century Fund study cited the case of a Mozart string quartet composed for a half-hour performance. This took two person-hours to perform in the eighteenth century and takes the same amount of time to perform today. In contrast, in the eighteenth century it may have taken two person-years to produce a watch of doubtful accuracy, while the manufacture of a modern electronic watch of astonishing accuracy and versatility requires only minutes of labor time.

All this means that costs in the arts, since they have been mitigated only by minimal increases in productivity, have

tended to rise, persistently and cumulatively, with significantly greater speed than those in manufacturing. In other words, the cost of live performance has an inherent tendency to outpace the economy's overall rate of inflation. With ticket prices rising at a slower rate than inflation, and with costs tending to rise more rapidly, the impediments to continued solvency of the arts organizations are all too clear. How, then, have they been able to overcome them?

On the revenue side, there are several parts to the answer, and most of them are felicitous. For one thing, there has been a remarkable increase in attendance. Here again, the orchestras and the commercial theaters are the main sources of documentation, and they tell similar stories involving a dramatic rise in audience size. Perhaps inflation played an indirect role here. One of our authors offers the hypothesis that attendance was stimulated by the very erosion in the purchasing power of ticket prices, that is, by the lag in ticket prices behind the economy's inflation rate, which makes attendance increasingly a bargain. In addition, inflation may account for the long period of erosion of the value of the dollar vis-à-vis other currencies that brought foreign visitors to our concert halls and theaters and encouraged attendance by Americans who found foreign travel too costly. In any event, whatever its causes, growing attendance has contributed more than in the past to the earnings of many groups, and in the case of commercial theaters it has constituted the prime source of their prosperity. The 1982 figures, however, which were not available when this chapter was written, indicate that this trend toward growing audiences may be grinding to a halt.

Nonprofit groups, of course, are highly dependent on philanthropic support as well as on box office revenues. A good half of the income of many such organizations is

derived from public and private contributions. It is, there-
fore, necessary to determine what has happened to their
contributed revenues during our protracted period of infla-
tion.

Here, too, there was reason for apprehension. For many
years private philanthropy has been affected by the incredi-
bly poor price performance of the stock market and the
accompanying fall in the prices of bonds and other fixed
income securities; and the declining values have bitten
heavily not only into the funds available to individual phil-
anthropists but, perhaps even more severely, into the re-
sources in the hands of the private foundations. Conse-
quently, there has been very good reason to fear that pri-
vate sources of funding would be unable or unwilling to
keep up with the rising costs of the performing arts.

Meanwhile, state and local governments have also found
themselves under severe financial pressures. This is not the
place to examine the reasons for this development in any
detail. A period of severe social problems (themselves not
entirely unconnected with inflation and the federal policies
undertaken to control it) has certainly played its share.
Moreover, many services of local governments such as edu-
cation, welfare, and police protection join with the arts in
being resistant to productivity increases and are therefore
also vulnerable to the cost disease and its financial conse-
quences. Such problems for vital state and local services
constitute strong grounds for apprehension about the abil-
ity of this portion of the public sector to keep the level of
contributions abreast with the cost of the arts.

The record shows that only one lag in support has oc-
curred—so far. Contributions from the private sector have
risen persistently and considerably faster than the general
rate of inflation. Until the accession of the Reagan admin-

istration, both the federal government and the states did even more spectacularly, multiplying and remultiplying their contributions, even as measured in dollars of constant purchasing power. Thus, on the revenue side, developments have generally been favorable to the arts in helping them to keep ahead of inflation. The only problem is whether one can expect these benign behavior patterns to continue indefinitely, and here, it must be admitted, one cannot be wholly and confidently optimistic.

During the 1981–82 season Broadway experienced its first decline in attendance in many years, though there is no reason to conclude that this decline is more than a temporary aberration. The increase in federal funding was abruptly reversed in 1982, and there has been no further increase in nominal dollars.

Participants in the conference certainly expressed doubts about the likelihood that private giving to the arts would keep up anything like its earlier rate of growth. The decision by the Ford Foundation to withdraw the bulk of its support from the arts is certainly not encouraging.

These facts are not cited as conclusive portents of an imminent financial crisis for the arts. Such dangers have threatened before; and, at least in some cases, the threat has, happily, not materialized. These developments are noted here merely as an attempt at balance, to show that recent trends in attendance and philanthropic support are no guarantee of any easy future. Past achievements have not come easily. Fundraising and audience building always demand enormous outlays of time and energy, and performing groups are finding that more and more resources must go into this effort to fund the arts.

Rather less well documented is the cost side of the bal-

ance of revenues and costs that the arts have been able to achieve. Have the arts been able to keep the cost disease at bay? If so, how did they accomplish this feat? Our evidence is limited, and the data that are available tell a story that is marginal. Consider the orchestras. Measured in some ways (cost per performance), they have succeeded in keeping the rate of cost increase behind the rate of inflation. Measured in another way (cost per attendee), the opposite conclusion holds. Neither measure is conclusive. It is perhaps suggestive that according to the historical data the costs of performance usually behave differently during inflationary periods than they do at other times. When prices in the economy have risen very moderately, remained constant, or even fallen, cost per performance has generally risen considerably faster than other prices, presumably at least in part as a consequence of the cost disease. But in inflationary periods cost per performance has tended to decline relative to prices in the remainder of the economy.

What is not certain is the means by which the arts have been able to prevent their costs from rising as rapidly as the general inflation rate. Two hypotheses have been offered, each supported by some amount of evidence. The first is that inflation is resisted by the simple expedient of holding down the compensation to the artists. Several of the chapters in this volume offer some pertinent figures. They suggest that here, too, the answer is close to the borderline. On the one hand, in at least some types of organization the purchasing power of the regular wage rates has, on the average, been eroded somewhat by inflation. On the other hand, at least in some cases performers' total *earnings* have increased faster than the rate of inflation, presumably because they put in longer hours or worked longer seasons.

Certainly the earnings of the superstars do not seem to have fallen behind, as is indicated by some fascinating new data that are provided in this volume.

A second way in which performing groups can hold back costs involves modification in their manner of operation. They may turn to plays with smaller casts, replace orchestral performances with chamber works, use simpler sets and costumes, have actors "double" in parts (i.e., one actor may play several characters in a single evening's performance), or reduce the number of rehearsals preceding a public performance.

The evidence confirms that all these things have been happening in recent years. One cannot be certain that inflation is the major cause, but that suspicion is strong and widespread among knowledgeable observers.

It is also a source of concern that pervades the chapters in this volume. The immediate worry is that there are limits to what can be done along these lines—that this source of economies must ultimately terminate itself. It is, perhaps, easy to go from a season of plays whose average cast size is 20 to a set of dramas with a mean cast size of 10. But such a process has an obvious stopping point; a future of 1- or even 2-person shows is hardly an attractive or a viable prospect.

Even more worrying is the long-run implication for quality. Of course, chamber music is not inferior to orchestral music—that is, not all such developments pose a threat to artistry. But reductions in rehearsal time; limitations upon the repertory to include only what is economically feasible; and reductions in production budgets, when moderate, can be inhibiting; when large, however, they may prove catastrophic. At least, this is the main fear of the consequences of inflation that recurs in the pages that follow. In

short, whatever success has been achieved in holding back costs may be as much a cause for worry as a ground for congratulations.

2. The Budget Cuts

The time at which the conference was held made it inevitable that the cut in federal contributions to the arts would appear in the discussions. It must be remembered that in that summer of 1981 the first proposal of the Reagan administration for cuts in the budget of the National Endowment for the Arts had not yet gone through the congressional process. A variety of compromises were under consideration, and only conjectures about the probable outcome were available. The appropriation eventually voted was equal to the previous year's with no increase for inflation, representing a real cut, but not as great a one as had been feared. All the evidence suggests, however, that if all other sources of funding were to continue to grow as they have, then a reduction in direct federal support would have negligible consequences for an average performing group. This is not because there is any likelihood that private philanthropy would leap into the breach. Rather, it is because direct federal support, despite the remarkable record of its rate of growth, on the average constitutes only a small percentage of the funding of artistic organizations; and, despite worries to the contrary, it seems on the average to constitute no larger a share of the funding of small groups than of the larger established organizations.

The main dangers of the federal budget cuts, however, are their demonstration effect, and the closing off of still another refuge should difficulties arise from other quarters.

We have already noted that there are reasons to fear a falling-off in support from private sources. Should this happen where government grants are provided on a matching basis (i.e., whereby the funds are actually given only if similar amounts are raised from private sources), the effect may be much more serious.

Moreover, recent changes in tax laws have been interpreted by many observers as being disincentives to private giving. For example, the reduction of the maximum tax on "unearned incomes" (such as interest and dividends) means that wealthy taxpayers can now in effect deduct only 50 percent of their philanthropic outlays, not 75 percent as previously. Thus, reduced federal expenditures and other accompanying federal actions may very well actually have the effect of discouraging giving from other sources rather than eliciting an offsetting upsurge in private funding.

Equally alarming is the cessation of growth in federal funding at a time when other sources of support offer prospects that are uncertain at best. Corporate support, while it has increased in recent years, shows some signs of receding in real terms during the present business recession. Should the most pessimistic forecasts of funding by private individuals, foundations, and state and local governments prove valid, to whom will the arts be able to turn?

3. The Arts as Family

There is an uneasy truce among the different branches of the performing arts—one beset by mutual suspicions. In the theater small experimental groups have doubts about the artistic dedication and contributions to the vitality of the drama by the larger, more established nonprofit the-

aters. The latter, in turn, are apt to feel that the off-off Broadway and far-off Broadway groups are tainted by amateurism. And both have been known to achieve unity only in their suspicion of the artistic integrity of the commercial theater which encompasses the extensive activity of Broadway and the road and attracts by far the largest part of the theater audience.

There are clear differences in the activities as well as in the financing of the three types of enterprise. Yet it becomes increasingly difficult to accept the view that they are separated by a sort of Berlin Wall. Financial pressures have forced each branch of the activity to depend increasingly upon the others. Many of the regional theaters draw heavily upon classic American plays that were first produced in the commercial theater. Broadway itself is finding the cost of trying out new plays so prohibitive that it is getting much of its new material from the subsidized theater. It surprises no one to find Joseph Papp financing free Shakespeare in the Park and the more innovative activities of his New York Shakespeare Festival with the proceeds of two Broadway hits, both of which were launched in his noncommercial facilities.

The underlying unity of the theater in all its manifestations was unexpectedly brought home to the speakers at the conference by its location at Las Vegas. One of the chapters in this volume reports that Las Vegas is one of the major centers of employment of performing artists in the United States. Relative to its population, Nevada actually leads the country in the number of musicians, dancers, and actors who work there. But even absolutely the numbers are significant. From the day we arrived we constantly ran into young people who had secured jobs as professional performers, who were deriving training and experience in the

process, and who hoped after some time to broaden their experience elsewhere.

But we found more than this. We encountered a type of performance largely beyond our experience that may, perhaps, be described as the megacommercial theater—productions whose budgets run into the tens of millions of dollars, and superstars whose weekly earnings are several hundred thousand dollars. We were offered a rare glimpse of the financial data about this exotic world and, more than that, of the processes underlying those operations and those financial figures. Those, too, are a treat available to readers of this volume.

But even more striking and memorable than the mere description of its economics was a performance that the speakers all attended. Just days before we arrived, the MGM Grand Hotel, which had just risen Phoenixlike from its much-publicized ashes, had opened a production staged by Donn Arden called *Jubilee* that really deserves to be called colossal. It is apropos to offer a brief description here. The gigantic stage is only the tip of the iceberg. With its fly space and subterranean levels, it encompasses six stories. The orchestra performs a few stories underground and maintains communication by means of closed-circuit television. The audience sits at tables, cabaret style, in a room covered from floor to ceiling with dark red velvet. Two drinks and the performance were $20 per person.

However, the heart of the evening is, of course, the performance itself, which undertakes no less than a history of the world as seen through the eyes of Las Vegas. The singing and dancing are plentiful and thoroughly professional; the costumes gorgeous; and there is even a bit of prim and charmingly old-fashioned nudity. Most overwhelming is the audacity of the production. After a series of impressive

spectacles it reaches its first climax in the Samson and Delilah scenes, including the destruction of what appears to be a stone temple, some three to five stories of barbaric splendor, which collapses and scatters over the stage amid enormous flames (yes, *flames*, not flickering red and amber lights). An even grander climax is no less than the sinking of the *Titanic*. The scene begins on a seemingly life-sized deck with the passengers boarding, settling down for the voyage, going through various little dramas. Then the girl appears, exuding sex, and after suitable preliminaries she is impelled to descend staircase after staircase (all full-scale and appearing magically out of nowhere) into the bowels of the ship, presumably in search of her hairy ape. There, among the giant whirling machinery, she is dancing seductively with the shovelers of coal when, suddenly, *it* occurs. The stage shudders; the machinery falls apart; and uncountable gallons of water pour down on everything. Then, magically, with no curtain having fallen over the spectacle, we find ourselves on the surface of the sea in a large lifeboat as, in the distance, the great ship shudders, is suddenly upended, and slides into the ocean.

All of us—from the universities, from the nonprofit theater, from far-off Broadway, from Carnegie Hall—were impressed, astonished, and delighted. The rest of the audience, many of whom may never have been to a professional live performance, were equally delighted. We had all shared a theatrical experience. The sheer joy of what can be accomplished by the marriage of imagination and professionalism had been illustrated, shall we say, dramatically.

It seemed ironic to us that the next day's discussions at the conference elicited from a resident a lament over the vulgarity and unworthiness of such Las Vegas performances.

The demonstrated fact was that this beautifully done mega-commercial performance could move persons with very little sophistication as well as those with the most impeccable credentials and loyalty to the most honored art forms. The performing arts and their audiences are indeed a family. If we reject any members of the family as unworthy, we run the risk of making attendance at those performances which are considered creditable something akin to a visit to a mausoleum. Surely the arts and the audience lose out when arbitrary borders are drawn between the activities that are worthy and those whose worthiness is suspect or beyond the pale.

4. Brief Survey of the Conference Papers

To include as many different viewpoints as possible, the participants at the Las Vegas Conference included theoretical economists, persons involved with the management of performing arts organizations, a banker, representatives of a private and a public funding agency, a critic, and a newspaper columnist.

Professor William T. White, Chairman of the Department of Economics of the University of Nevada at Las Vegas, conceived the idea of the conference and was its prime mover. Academics became his second career after retirement from the U.S. Air Force, and he is the author of many monographs and papers. In his opening address to the conference, which appears as an appendix to the volume, Professor White proposes a university-based center for the study of the arts, pointing out the symbiotic relationship among them.

We asked Joe Delaney to speak at the conference because he was a local commentator on the performing arts

scene, and were delighted when we struck oil. Anyone working on performing arts research who has tried to obtain information about the remuneration, perks, and special arrangements of the superstar knows what it is to face a blank wall. No one talks. Yet, as Michael Walsh points out is his contribution, great names are what the public is demanding increasingly.

A superstar is a performer who can fill the house, and anyone who believes that in economic terms there is very much difference between Dolly Parton and Luciano Pavarotti is romanticizing. Joe Delaney lays bare for us, perhaps for the first time anywhere, that secret world—the figures, the deals, the performer, and his or her retinue as big business. He feels that the consumer is often victimized by inflated prices, missed performances, and the caprices of the superstar. Despite his wistful desire for a return to the old ways, Joe Delaney knows that this phenomenon is a fact of life, not only in the Las Vegas hotels and rock concerts, but also in the best-known opera houses. His important paper tells this story "like it is." Joe Delany has been the columnist and commentator for the *Las Vegas Sun* and radio station KDWN for over twenty years.

Professor Alan T. Peacock, Principal of the University College of Buckingham, economist, Fellow of the British Academy, Chairman of the Arts Council Enquiry on Orchestral Resources, and member of the Council of the London Philharmonic Orchestra, to cite a few of his most relevant honors, was keynote speaker of the conference. Professor Peacock is preparing a two-year study, "Measuring Inflation in the Arts," for the Arts Council of Great Britain; his chapter, "Economics, Inflation, and the Performing Arts," with its emphasis on techniques of survival, draws on this unfinished work.

There were two special reasons for the invitation to Professor Peacock. The first was to obtain the preliminary findings of an important academic study of the performing arts on a platform sponsored by a major university. The second was that the similarity of the problems of the English arts world to those of the United States underscores the "one world" aspect of the arts. Not only do the arts throughout the world often share a common language, but they share similar financial constraints.

Dr. Russell Sheldon is Senior Economist at the Mellon Bank in Pittsburgh and is frequently assigned the task of speaking to performing arts organizations. An econometrician who has published papers in the *Review of Economics and Statistics,* the *Southern Economic Journal,* and the *Survey of Current Business,* Dr. Sheldon has traced the effects of inflation particularly on members of the American Symphony Orchestra League and has the gift of being able to describe the progress of inflationary pressure in layman's language.

The interest shown by the Mellon Bank in the nonprofit performing arts is, perhaps, a portent of the interest business will take in the performing arts in the future, as many hope it will do in order to fill the gap left by the erosion of public support.

The plight of the small theater is discussed by Richard Reineccius, Director of the 99-seat Julian Theatre in San Francisco. He teaches courses in theater arts at San Francisco State University; was a founder and served as an officer of the Neighborhood Arts Program, which received national attention; was founder, with the help of the Theatre Deveopment Fund, of Performing Arts Services for the Bay Area; charter board member and Vice-president of the California Theater Council, and served as a Commissioner

on the San Francisco Arts Commission. His discussion of "far-off" theater refers to the geographic distance from Broadway, and can be applied to "off-off," "off-Loop," or small professional theaters anywhere. He is unique among the conference participants in being a performing artist himself, and has twice been nominated for outstanding performance by the San Francisco Bay Area Theater Critics' Circle.

The inclusion in the conference of this tiny area of the performng arts is not fortuitous. It has an importance belying the meager resources it requires. Small theaters have always been part of the American scene. Local stock companies were the typical form of organization before theater became big business in the last quarter of the nineteenth century,[2] and their remnants have survived to serve as testing ground and laboratory; as a platform for new actors, playwrights, directors, scenic designers, and to provide their successes to the established theater and the media. Richard Reineccius, while discussing the effects of inflation upon his operation, does not attempt any formal systematic analysis, but the very nature of his ruminations gives us the flavor of the operations of the smaller theaters.

It seemed appropriate to follow Mr. Reineccius's account of the mini-economies of the 99-seat theaters with a description of the way the Broadway theater copes with similar pressures. Irving W. Cheskin, in his position as Executive Director of the League of New York Theatres and Producers, Inc., has not only been an observer over the past twenty years of the emergence of the Broadway theater industry from "fabulous invalid" to a thriving modern business but has played an important part in this transformation. He has now retired as Executive Director and remains with the league as Director of Pension and Welfare Affairs.

Herbert Weissenstein has been Director of Development of Carnegie Hall since 1979 and, before that, worked as artists' representative and had managerial positions with several major symphony orchestras. His chapter deals with "Inflation and Standards of Quality in the Performance of Music." His impression is that quality, at least at places such as Carnegie Hall, is being maintained. His personal forebodings are that the adjustment required to keep budgets more or less in balance may yet undermine quality in the long run.

Mr. Weissenstein is quite young, and new to the world of conferences. We were struck by his broad understanding of the business of the performing arts. It is also vital that his message be disseminated, because in the inflationary world the individual manager is so concerned with the need to hold the budget in line that he can devote little thought to advancing artistic standards.

Still on the subject of quality, Michael Walsh, graduate of the Eastman School of Music and music critic for *Time,* deals with a different kind of inflation perhaps even more destructive over the long run than the financial one—an inflation of expectations on the part of the audience. Mr. Walsh was formerly a music critic for the *San Francisco Examiner* and the *Rochester* (N.Y.) *Democrat and Chronicle.* He is secretary of the Music Critics' Association and was the 1980 recipient of the ASCAP Deems Taylor Award for distinguished criticism.

Mr. Walsh's chapter was conceived as a companion piece to the preceding one by Mr. Weissenstein. While the former is concerned with a pause in the quest for artistic advancement, Mr. Walsh talks of the consequences of the economic broadening of the audience base so necessary in the long run, and of the need to attract greater and greater

numbers of people with the aid of popular programming and superstars. What he calls the "inflation of expectations" manifests itself in the temptation to present performances acceptable to the broadest possible base. When this view is juxtaposed with Joe Delaney's discussion of the insatiable demands of the public for performance presenting superstars, one is forced to consider the portents for the future of the arts. Are we dealing with a kind of inflation more insidious than fiscal that knows no respite?

It was unthinkable to hold a conference on the arts without a representative from the National Endowment for the Arts, not only because of its financial support role, but chiefly for the immense influence it has had upon the dissemination of the arts throughout the country and its encouragement of funding from other sources. Harold Horowitz has been Director of Research of the NEA since 1975, holds a master's degree in architecture from the Massachusetts Institute of Technology, and has worked in architectural research and in managerial positions that include the Albert Farwell Bemis Foundation at MIT, the National Academy of Science, the National Science Foundation, and the Energy Research and Development Administration. His contribution to this volume is a chapter presenting the results of an NEA study on the effect of inflation on the performing artist. He traces the trends in earnings and employment that can be discerned from the available statistics and indicates where future research is required.

Hugh Southern has been Executive Director of the Theatre Development Fund (TDF) since its inception in 1968, and since then there are few areas of the performing arts that have not felt its benevolent hand. TDF's most visible achievement is the establishment and operation of the Times Square Theater Center, since copied in London and

elsewhere, which disposes of unsold tickets at half price. It operates a loan program for established theaters, a voucher program for small arts organizations, a nationwide development assistance program, and a popular costume loan service. Mr. Southern's comments on sources of support, "The Tune and the Piper," are informed, practical, and sobering. Mr. Southern graduated from King's College, Cambridge University, in 1956. Before joining TDF he was associated with the Westport Country Playhouse, the Theater Guild, the Lincoln Center Repertory Theater, the National Repertory Theater, Expo '67, and the San Francisco Opera. He is a member of many public service organizations and has since left TDF to become Deputy Chairman for Programs for the National Endowment for the Arts.

Mr. Southern's paper sums up the fears of arts administrators everywhere that business in general is not prepared to give something for nothing. They fear, on the basis of experience, that business aid to the arts will be contingent on the right to monitor programming to ensure presentation of the "proper image."

2

The Performing Arts in Las Vegas: Impressions of a Journalist

Joe Delaney

THE story of the economics of the performing artist and the story of the growth of Las Vegas are the same. Nowhere and in no other medium has the artist achieved the financial returns that have been realized in Las Vegas. Meanwhile, all the inherent evils in the business exist here as well.

1. Earlier Days

Inflation in the arts—where does it start? Where does the fault, if any, lie? With the artist, his personal manager and/ or agent, the hotel entertainment director, all of them or none of them?

Prior to the 1950s, an entire show cost might be less than $25,000 per week. Today, top hotels are looking at a budget of $300,000 per week and more; 15 million per year for just one hotel!

In 1950 the top star salary was $25,000 per week. At that

time, the hotels were controlled by the casino. The original places were built so that you went through the casino to check in, go to your room, eat, go to the bathroom, attend a show, sit in the lounge, go swimming during the day, whatever.

The casino was the fulcrum. Decisions were made by individuals, rugged individuals, street people who were great students of human nature. They understood human needs and, particularly, human greed.

They knew that the important thing was to get you to Las Vegas, then give you the best possible entertainment, food, beverages, and service at the lowest possible cost, or at no cost; and you would go into their candy store, the casino, and give them your money, then go home and plan to return as soon as possible.

It worked very well. Las Vegas gave—and it received much more than it gave. It worked so well that Howard Hughes started buying hotels and casinos. The coming of the corporation was hastened by his activities.

The corporate credo that evolved was: every room and each activity in the hotel must show profit. "Whatever the traffic will bear—and a little bit more" became the modus operandi. Overly high prices and resultant customer dissatisfaction have caused a courtesy crisis as well as a diminuation of entertainment attendance. Las Vegas corporate thinking is almost entirely short-term.

Back in the 1950s, the bosses got together and said that $25,000 was their limit for any headliner. A few weeks later, a star moved from one hotel to another. The two owners were friends. Owner 1 asked owner 2 what had happened.

Owner 2 said, "Beats me, I'm paying him the same $25,000 that you were. Would you care to see the con-

tract?" The contract price read $25,000. Owner 1 did a little private investigating and learned that his former star was now picking up $2,500 a week in cash at the casino cage, the equivalent of at least double that amount if reported to the government.

These were the "under-the-table" payments; so much on the contract and so much under the table. This method flourished until 1955 when the Riviera Hotel opened its doors. Liberace had just finished his contract period at another hotel. Lee asked for and received $50,000 per week, a new plateau.

What did this do for the stars who were headlining at the other hotels? It brought them up to $50,000; at least it did for those who did strong casino quality business. When Frank Sinatra, at the Sands, heard that Liberace was receiving $50,000, you can make book Frank was not going to work at the Sands for $49,500.

2. Evolution

When Caesars Palace opened its doors in 1967, Las Vegas had achieved the $100,000 per week plateau. Bill Miller, one of the visionaries, a great entreprenuer, believed, "Aim big, hit big." It was also true, "Aim big, miss big." Bill had some colossal hits, equally large misses, but his overall average was excellent.

Miller was entertainment director when the International, now the Las Vegas Hilton, opened its doors in July 1969. Barbara Streisand opened the hotel for Bill, followed by Elvis Presley, who before his death set some all-time records at the Hilton, and Nancy Sinatra.

Perry Como, Bill Cosby, Don Ho, Danny Kaye, and Gene

Kelly were others who were brought into the International fold by Miller as he established a new plateau at $125,000 per week.

The MGM Grand opened in 1973, and needed a stable of stars for its Celebrity Room operation. The MGM Grand has two main showrooms: one for star policy, and the other, the Ziegfeld Room, for massive production shows such as the current incumbent, Donn Arden's *Jubilee,* a $10 million spectacular.

How did the MGM Grand get stars? It paid them more money. The top salary for the superstars was now $150,000 per week. There has not been a major hotel opening since, and the headliner maximum locked in at somewhere between $150,000 and $200,000 per week. There were additional benefits, such as use of a company home, limousines, food and beverages, maid and butler service, and so on.

Along came a man named Meshulam Riklis whose billion-dollar conglomerate gained control of the Riviera Hotel. Riklis is married to a young performer named Pia Zadora. At his insistence, Pia was pressed upon various superstars to be their opening act.

The timing was ideal for the MGM Grand. Several top stars left the Riviera and moved to the MGM Grand, at much higher salaries thanks to the MGM's need for stars.

Riklis did his real damage to the hotel star relationship when he decided to sign Dolly Parton at $350,000 per week, or $50,000 per night, $25,000 per show, predicated upon two shows a night, seven nights a week. Top stars at other hotels, such as Frank Sinatra, now at Caesars Palace, the leader, went to $25,000 per show.

In fact, we understand that Mr. Sinatra now receives $50,000 per night whether he does two shows or only one. The option is his.

Has Dolly Parton been worth $350,000 a week? We don't know because she has yet to work a full week. Apparently, she cannot handle the grind of two shows a night, one at 8:00 P.M. and the other at midnight. If she could, would she be worth it?

Perhaps she could at the Hilton with its 2,000 seats. The Riviera has half that many. One thousand seats twice a night totals 14,000 people per week. The hotel would have to net $25 per seat just to pay the fee, which would not include cost of musicians, stagehands, culinary personnel, food and beverage, showroom upkeep, and the additional benefits for the star mentioned above.

It is our considered guess that the Riviera would have to net $50 per person to break even for the week. One alternative that was considered: have Dolly Parton work dinner shows only and a comedian like Shecky Greene or Buddy Hackett work the midnight show. The problem: Would both parties concerned work for 50 percent of their regular weekly stipend? Would Dolly work for $175,000 a week?

The question is moot now. The Riviera has opened its new Superstar Convention Center and it hopes to have Dolly work there weekends only, playing to crowds of 2,500 two shows a night, a total of 10,000 people paying an average of $30 per person. Just for admission!

Neither of these solutions is original with the Riviera people. The concept of separate shows, dinner and midnight, has worked successfully in the past at the Sahara, thanks to Buddy Hackett, who opted to work midnight shows only at 55 percent of his regular salary. Jerry Lewis agreed to a similar arrangement, working dinner shows only. There were other star combinations.

The Sahara brass figured that it was better to have two full houses and pay 110 percent than pay either star 100 percent to do two half houses a night. This was working nicely until

the Del Webb Corporation got into deep financial trouble and decided to go low-budget shows, revue type, a disaster thus far. It is possible to "save" yourself out of business in Las Vegas.

The idea of a Superstar Convention Center originated with the Hilton people who built the Las Vegas Hilton Pavilion as a place for Elvis Presley to play one show a night for 5,000 people while the regular showroom was featuring stars like Liberace and Bill Cosby, two shows a night, approximately 1,000 people per show, for a total of 7,000 people per night. Ironically, Presley's death occurred on the day the Hilton was officially opened.

3. Pricing in the Corporate Era

Last night a group of you went to see Donn Arden's new *Jubilee* at the MGM Grand, a $10 million investment. It started out as a $5 million project, was interrupted by fire, and wound up costing $10 million.

The MGM Grand wisely decided to charge $20 admission as a two-drink minimum. In remodeling the room after the fire, the hotel picked up an additional 158 seats, resulting in an additional $3,160 per show gross income, and additional 2.3 million per year. The hotel expects to net about $5 million per year. The show should run at least six years as is.

The MGM Grand is the most successful hotel operation of all time. Even the things it did wrong turned out to be right. A costly miscalculation was made in planning the two showrooms. The Celebrity Room's capacity was 1,500 at midnight, approximately 150 less for dinner; the Ziegfeld Room, for production shows, sat less than 1,000.

It should have been the other way around. A calamitous fire enabled the owners to enlarge the Ziegfeld Room and to change the decor of the steel gray and blue Celebrity Room to a much warmer burgundy. The investment in physical plant for the *Jubilee* showroom was enormous but well spent.

Recently, the minimum for *Jubilee* was raised to $22.50. Multiply $2.50 times 1,118 seats times 14 shows per week times 50 (the show is off two weeks in December); this additional figure is net profit. The cost of pouring a drink is under 30 cents; bottles of wine and champagne cost from $2.00 to $15.00 wholesale, and they charge between $10.00 and $50.00 per bottle in the two showrooms.

We repeat, the corporate philosophy has become: "Whatever the traffic will bear—and more."

Another example: Siegfried and Roy moved from the Stardust "Lido" to the Frontier where they are stars of their own production show *Beyond Belief.* The Frontier spent $3 million just remodeling the showroom and surrounding area. The opening night minimum was $20.00. When the MGM Grand moved to $22.50, so did the Frontier.

The four top hotels in Las Vegas, in alphabetical order, would be Caesars Palace, Hilton, MGM Grand, and Riviera. Caesars Palace and the Riviera have the cream of the heavy players, but they also go for the mass market, in the showrooms as well as at the casino.

Sidebar: the Flamingo Hilton goes for junkets and tours; a tightly run ship in an ideal location, sharing four corners with Caesars, Dunes, and MGM Grand, is a better bottom-line money maker than its sister Hilton Hotel.

The Flamingo Hilton features a production show *City Lites*. This is one of the reasons for the Las Vegas Hilton trying the production show format, starting September 1,

1982. Just for the record, the two top Hilton star headliners, Bill Cosby and Liberace, bring people in at a cost of between $5 and $10 per person.

Prior to the coming of the corporation, the rule of thumb was that an act that cost under $10 per person, if they did adequate casino business, was considered profitable.

This cost per person figure is arrived at by taking the total cost of operating the room and the net income after taxes, and comparing the two. If the cost is higher, divide it by the number of seats occupied during the week. If the gross income exceeds the cost, do the same. The first figure would be the cost per seat; the second, the profit per seat.

Maynard Sloate, show producer-entertainment director at the Union Plaza in Casino Center, claims a small profit per person on an annual basis doing comedy-dramas and an occasional Broadway musical. The MGM Grand Ziegfeld Room and the Frontier Music Hall, now drinks only shows with Siegfried and Roy, are others that should show an annual profit.

Caesars Palace, prior to the takeover by Cliff Perlman, was noted for having the best overall food and service. The Circus Maximus showroom food and service, at quite reasonable prices, were the best and nicest in the city. The reason was Bill Weinberger, whose first love was, and is, food and beverage plus great service. Billy is now running the Bally Park Plaza operation in Atlantic City.

The Perlmans put profit and expansion first. Caesars World is about to buy the shares of the Perlman brothers for some $98 million! Unfortunately, their plan also includes retaining Cliff as board chairman for a five-year period at full salary.

First, the Perlmans phased out dinner at dinner shows without passing any of the resultant savings on to the cus-

tomer. An attempt was made to have other major hotels follow suit. It was some time before a few did. Today, only the Flamingo, Hacienda, Hilton, MGM Grand Celebrity Room, Riviera, Sahara (sometimes), and Union Plaza serve dinner at their 8:00 P.M. shows.

The Perlmans were also responsible for an abortive ten-month attempt to install Ticketron-type seating, reducing the maîtres d' and captains to the status of ushers. It didn't work. This wound up costing Caesars over $2 million, and resulted in a reduction of showroom morale and a feeling of tension between management and labor that still exists.

Today, at Caesars, with a roster headed by Frank Sinatra, which includes Ann-Margret, Sammy Davis, Jr., Tom Jones, Diana Ross, and newcomer Wayne Newton, the Circus Maximus charge is $35 to $50 for the privilege of walking up the stairs and negotiating with the maître d' and captains.

Taxes and tokes (tips) are extra. Drinks are optional and extra. Once you could have dinner and see Sinatra perform for approximately $30 or $60, plus tokes per couple. An evening out with dinner elsewhere and a $50 showroom minimum can cost a couple between $200 and $250, total, depending upon their life-style. The net result has been that none of the Caesars Palace stars, including Sinatra, is able to do enough business for two shows a night. As I said before, Sinatra determines whether he will do one or two shows on a given night; his pay remains the same, either way.

This is a radical departure from the original thesis of filling the showroom twice a night even if you had to give the seats away. Thirty years ago, at a midnight show, coffee or a soft drink cost you 25 cents; or you could opt to have nothing and see the show!

Another Caesars Palace innovation: at one time, you

could take out your full minimum for two people in wine. If the minimum were $20 ($40 for two people), you could have $40 worth of wine. Caesars instituted the policy of one bottle of wine for each two minimums. All the other hotels followed suit.

Under the Perlmans, Caesars Palace has achieved economic segregation. People who are not willing to spend $35 to $50 to see the Caesars Palace stars, plus paying tax, tokes, and extra for drinks, are not welcome in their showroom.

Hotel owners in general could learn much from the girls who take the show reservations via phone and in person. The people who call in today are asking what the price is, what the figure comes to with tax, if there is a meal included, what the different entrée prices are and if they get one bottle of wine or two.

Why? Because money is tight and people are shopping today. They want full value for their money, and those showrooms that are providing it—assuming, that their attractions are competitive, such as the Frontier, Hilton, MGM Grand, plus the Union Plaza, downtown—are doing business.

Our gut feeling is that the Hilton decision to abandon the star format and go to a French-styled production show will be a costly, short-lived experiment.

One does get value for money at the Hilton, there is an $18.50 entrée at dinner; you can order one drink only at dinner and midnight drinks-only prices are just $15.50.

Returning to Caesars Palace, during the pre-Perlman period, Steve Lawrence and Eydie Gorme were working in the Caesars Palace Circus Maximus. The midnight show minimum was $10.00. They had never played to an empty seat in the 1,200-seat showroom.

Steve and Eydie's onstage format called for twenty minutes together, twenty minutes of Steve, twenty minutes of

Eydie and another twenty to thirty minutes back together. Steve would use his time offstage to wander through the audience, checking the sound and audience reactions. One night there were 400 hundred empty seats. Steve was appalled.

He picked up a table tent and noticed that the midnight minimum was now $15. The next day he was in Billy Weinberger's office. Weinberger brought in an assistant, who explained that 800 times $15 added up to $12,000, the same gross as 1,200 times $10. Lawrence, a good businessman, asked if it were better to have 800 or 1,200 people in your casino at 1:30 A.M., happy people who have just enjoyed a show? He also asked them to check the average expenditure per person at $10 and at $15. It was nearly the same. Several days later, the room went back to the $10 minimum and filled up once more. I really thought this would be a clincher. It hasn't been. For instance, the MGM Grand charges the same minimum for the midnight drinks-only show as it does for the Celebrity Room dinner show, $30. The midnight show counts have been off. At $20, the midnight show would pick up 200 to 300 bodies. This has been proven but not to the MGM brass's satisfaction.

4. Relations with Performers

The old-line performer was represented by an agent. Today's stars have a personal manager, an agent, a business manager, a publicity rep and a road manager. They receive percentages that amount to 35 to 50 percent of the performer's gross income. The breakdown in percentages: personal manager (15 or 20), agency (10), business manager (5 or 10), publicity rep (5), and road manager (5).

In the pre-1950 period, one dealt directly with the per-

former or his agent. Today, in addition to the above, there may be an attorney and an accountant who are part of the picture. The more the artist-performer makes, the more each member of his team earns.

Sometimes one person tried to fill two or three of the above positions, at an increased percentage, of course. To complicate matters further, many stars are now corporations. The star is no longer a human being whose only concern is doing his best job onstage.

What can be done? There is one man who has coped with the entertainment problem through the years. His name is Ed Torres, a cold fish, one of the best operators this town has ever known. From the Fremont to the Riviera to his present position as Wayne Newton's partner in the Aladdin Hotel, Torres has had a succession of winners.

He says to the performing artist: "The showroom is my room and these people are my customers. I am employing you to work in my room. I expect you to do enough business so the salary I am paying you will make sense.

"I will tell you how loud the show will be and how long it can run. If you are too loud you will drive my customers out of the room, and possibly, out of the hotel. If you run ten minutes over, it could cost me as much as $100,000 in the casino.

"If you wear people out, they will not want to gamble, they will go to their rooms instead.

"I will not tell you what to do artistically; it is to your benefit to do the best show possible each time out. You may have ten minutes extra, for acknowledgments, on opening night; otherwise, one hour and thirty minutes is the limit, an hour and twenty would be better."

Ed Torres also sets a limit on what he will pay. When an artist or his corporate representatives comes to him for more money than that limit, Torres will wish him well and tell

him he is free to go elsewhere when his present commitment is finished. Torres has a prepared speech for these occasions.

"As soon as your contract with me is up, I want you to make a deal elsewhere. I want to be your friend. If your price comes down to my maximum, I would like to employ you again. If I can ever afford more, I shall call you."

Wayne Newton, the performer, is a different person from Wayne Newton, Mr. Torres's partner in the Aladdin. As a performer, Newton was notorious for going overtime. Dinner shows would run two hours plus. It was not unusual to have his midnight show break at 3:00 A.M. and later.

Summa Corporation, his previous employer, absorbed the overtime and most of his other indulgences and their costs. Pleas from the casino operators and hotel managers fell on deaf ears. The union contract provides that the band must be off, between shows, for a time equal to the length of the first show before starting the midnight or second show.

Ed Torres told his partner that all overtime costs at their Aladdin would come out of Newton's personal pocket. Now you can set your clock by him. At 9:55 P.M., the eight o'clock show is over. The midnight show never goes past 2:00 A.M.

Liberace, at the Hilton, affords a similar example. "Lee" was notorious, not as bad as Newton, but a consistent overtime offender. This ended when Hilton renewed his contract at a substantial increase. The new contract contained a clause that provided that Liberace would assume all costs for overtime. There has been no overtime since.

5. General Strategy: The Bottom Line

I teach a course in hotel entertainment, a three-credit course, part of the College of Hotel Administration curricu-

lum. There are two key phrases: "square footage" and "bottom line."

Square footage is subtitled, "utilization of space." The entertainment director is given an area. The area may be in a new structure, in which case he can create a room to serve his purpose and set his own specifications.

In most cases, the room is in existence and may have to be converted or remodeled. When you are finished, will that room serve the best interest of your hotel? Will it attract and hold the clientele you desire?

I teach the students to psyche out a town—to read and understand the columnists, newspapers, and the trade magazines; to analyze radio and television, locally; and to put the various media to their best use.

We cover every type of entertainment room from a piano bar to *Jubilee* at the MGM Grand, including entertainment units, star policy, revues, and dinner theater. Students are taught the functions of the various trade unions. We visit various showrooms so they can see and understand various physical plants. Many top stars have shared their experiences with the class. I am in my ninth year teaching at the University of Nevada at Las Vegas.

The bottom line deals with the business end of show business. The bottom line in Las Vegas, Reno and Tahoe, and Atlantic City as well is different from the bottom line in other entertainment-resort areas that do not have legalized gaming.

In Las Vegas and the other gaming areas, we have the casino to pick up the slack, to cover controlled losses in the showrooms, lounges, and gourmet restaurants. The key word here is "controlled." Remember the original rule: If the show can be brought in to cost no more than $5 to $10 per person, with decent casino play, it is a 'profitable' show.

Remember our original formula was the best possible

entertainment, food, beverage, and service at the lowest possible prices and the visitor will give us the rest of his money in the casino. It worked well enough to attract Howard Hughes and the corporate investors that came immediately after him.

One of our forms of corporate delusion is the explanation that we are not as expensive as New York City, Chicago, San Francisco, and Los Angeles. We're not as inexpensive as we could be; that's one of the things wrong with us today.

The rule of thumb in gaming, a first requisite, is that you set both a win limit and a lose limit. For instance, you will stop when you lose $100. You will also stop when you win $50, or $100. That's a form of money management. If you win $100, you have doubled your money.

When you go to the bank and open a savings account, you are happy with 5.5 percent return over a one-year period. That's $5.50 on your $100 investment. By what rational thought process do we expect to double our money in a matter of minutes in a casino?

Gaming can be a great form of relatively harmless risk taking, provided we do not go to an excess. Gaming was not working that well in Las Vegas until entertainment, food, beverage, and very special service were added; then we became one of the fastest-growing areas in the United States.

Our problem in the years to come will not be the proliferation of gaming in other states but what we have done to ourselves in Las Vegas in departing from our original successful formula.

6. Prospects of the Star System

Returning to the problem of the artist, really our problem with the artist, most of the performers have spent twenty

years or more achieving their star status. Most of those twenty years saw them earning little or no income.

There are very few overnight successes. The overnight successes usually disappear overnight. When performers finally achieve success, they are entitled to whatever the marketplace will pay. Tomorrow, they may be out of vogue again.

The performing artist and the entrepreneur, in the case of Las Vegas, the hotel entertainment director, should have an adversary relationship. Let me amend that to the team that guides the artist manages his career. The artist wants the most; the entertainment director wants to pay the least and still keep the artist happy.

You have the facts, the most important facts, that have brought Las Vegas to its present transient point, a proliferation of revues and spectaculars. Is the star system dead? Dying?

Our contention is that the star policy system is ailing. What is needed is a more practical attitude on the part of the performers and their advisers; at the same, time, the corporate entities must return to the basics that made them invest here originally. They also need to employ entertainment directors who have budgets to follow plus the artistic freedom to be creative. This is the direst need from the corporate standpoint.

7. Visual Arts and Classical Performance

With the reader's indulgence, I shall use part of my time to discuss the classics in Las Vegas. Consider the University of Nevada, Las Vegas Master Series, under the direction of septuagenarian Charles Vanda. We are in our sixth season, opening with Zubin Mehta and the New York Philharmonic,

an eight-concert series that includes André Previn and the Pittsburgh Symphony and closes with *The Mikado*.

The Master Series has been sold out for six seasons. It has money in reserve, yet it functions without federal, state, or local subsidy, on subscriptions alone; name one other classical series in the United States that can say this.

That's pretty impressive for Las Vegas, which has always been referred to as a cultural desert. We are proud of Charles Vanda in Las Vegas. He is representative of the majority of people who love, live in, and support this community.

Charles and I have had a running battle. I want him to book James Galway, the flutist, into Ham Hall. Charles has refused because Galway's people want too much money. When we first started this hassle, Galway's price was $8,500; now it's $20,000. Vanda's defense is that it was too much then and it is still too much for what he can do in Las Vegas. Charles is right, just as Ed Torres is usually right.

Where does inflation originate? Did Liberace cause it in 1955 when he demanded and received $50,000 from the Riviera Hotel? Did the Riviera start the ball rolling by giving him the $50,000? Aren't we in a chicken-and-egg, which-came-first situation?

Inflation in the performing arts is harder to define than it is in other situations because a performance is worth whatever it is worth to you. To the person who pays the $50 to walk up the Caesars Palace Circus Maximus stairs to see the maître d' for a seat to Sinatra, it may seem a reasonable price, worth it.

I have two original paintings by an artist named Morris Graves. I bought them for $550 apiece in the late 1950s. Charles Laughton, the actor, was one of Graves's patrons. When Laughton died, he left his collection of Graves's paintings to the Museum of Modern Art.

When the museum wanted to have a Graves exhibition, I

was approached by a third party whose research had revealed that I was the owner of two Japanese ink paintings of birds, missing from a certain period in Graves's career. He wanted to buy the paintings for the museum.

I offered to loan them to this party for the exhibit with a credit plaque. He offered as much as $5,000 apiece for the two paintings. I refused. These paintings are personal to me. When I pass on, my widow may decide to dispose of them. They may not bring nearly that much.

They could be worth more. They were suddenly worth $5,000 because there was a demand at the moment. I have friends who have looked at the two paintings and said they wouldn't give me $5 for the two, combined.

There we have examples of both inflation and deflation in the arts; the pictures in question are as they have always been. Remember what happened to Monet's paintings of lily pads in the 1950s? Monet became a vogue, and they appreciated in value tremendously.

In Las Vegas, as with every other place of the arts, we will have periods of inflation and deflation. Our problem at this point is rehumanizing the corporate structures, at least where their approach and attitudes toward entertainment are concerned.

I leave you with this thought: If Las Vegas could go back to the 1950s and $25,000 a week maximum salary for a star, how long would it take before "under-the-table" payments were resumed, a new hotel would open, and a new salary plateau established?

Is it all not cyclical—and relative?

3

The "Taxpaying" Theater: How Has It Fared during Inflation?

Irving W. Cheskin*

S INCE this is the second day of the conference, I am reminded of an exchange of telegrams between George Bernard Shaw and Winston Churchill, who were good friends.

Mr. Shaw sent Mr. Churchill a telegram in which he said, "I cordially invite you to attend the opening night of my new play—and bring a friend—if you have one."

The response from Churchill was immediate: "I regret that I cannot attend the opening, but I will come second night—if you have one."

To my knowledge, this is the first time a conference has been held to consider and evaluate the effects of inflation on the performing arts by a group of arts administrators and professional economists. I shall restrict my comments to the commericial or "taxpaying" theater and, more specifi-

*I want to express my appreciation to our director of research, George Wachtel, who prepared the data that I have utilized throughout his chapter. I am, of course, accountable for the conclusions.

cally, to the Broadway legitimate theater and the touring productions that flow from Broadway.

1. The "Taxpaying" Theater and Its Traditional Role

What is the "taxpaying" theater? Apart from the creative and performing talent, it consists of producers and theater owners. They are very creative and highly individualistic personalities. Briefly, the commercial theater consists of 43 legitimate theaters in the Broadway area and about 38 major legitimate theaters across the country. Ten years ago we had 36 legitimate theaters and 37 major legitimate theaters on the road, so although the numbers of theaters remained approximately the same on the road, Broadway increased its theaters by 7. The 43 Broadway theaters vary in size, ranging from houses with only a few more than 300 seats (of which there are very few) to houses holding nearly 2,000 seats. The road houses average 68 percent more seats, with several popular theaters seating between 2,000 and 2,300. (See Table 3.1.)

In the past 1980–1981 season commercial theater grossed approximately $200 million in New York City and approximately $220 million on the road, for a total of $420 million. Ten years ago the Broadway theater gross was approximately $55 million, and comparable road grosses were $50 million, or a combined total of $105 million. In nomi-

Table 3.1
Size of Theatres

	New York	Road*
Average	1,120	1,881
Range	299–1,778	342–4,319

SOURCE: League of New York Theatres and Producers, Inc.
*Most active theatres, 1981–82 season.

Table 3.2
History of Gross Receipts
(millions of dollars)

	Broadway		Road	
	Actual	Constant Dollars (1972 = 100)*	Actual	Constant Dollars (1972 = 100)†
1954–55	$ 30.8	$ 51.4	$ 21.2	$ 33.0
1955–56	35.4	59.5	22.9	35.8
1956–57	37.2	61.6	19.8	30.5
1957–58	37.5	60.1	22.6	33.6
1958–59	40.2	62.5	23.4	33.9
1959–60	45.7	70.2	27.3	39.2
1960–61	43.8	65.9	34.0	48.0
1961–62	44.3	66.1	39.2	54.8
1962–63	43.5	63.9	31.6	43.7
1963–64	39.4	56.7	34.1	46.6
1964–65	50.5	71.5	25.9	34.9
1965–66	53.9	75.1	32.2	42.7
1966–67	55.1	74.3	43.6	56.2
1967–68	58.9	77.4	45.1	56.5
1968–69	57.7	72.7	42.6	51.2
1969–70	53.3	63.2	48.0	54.8
1970–71	55.3	61.1	49.8	53.7
1971–72	52.3	54.6	49.7	51.3
1972–73	45.3	45.3	55.9	55.9
1973–74	46.2	43.5	45.7	43.0
1974–75	57.4	48.7	50.9	43.2
1975–76	70.8	55.8	52.6	40.9
1976–77	93.4	69.6	82.6	60.7
1977–78	113.8	80.6	106.0	73.2
1978–79	134.0	89.8	140.6	90.2
1979–80	146.3	90.2	181.2	104.4
1980–81	197.0	109.1	218.9	111.1

SOURCE: League of New York Theatres and Producers, and *Variety*
*CPI all urban consumers; N.Y., N.Y.–northeastern New Jersey.
†CPI all urban consumers; U.S. city average.

nal dollars in the last decade, we increased our Broadway and road grosses by about 300 percent each. (See Table 3.2.)

By utilizing a local and national economic multiplier (devised, incidentally, by Professor Baumol in a study for the League of New York Theatres and Producers), it has been calculated that the legitimate theater in the 1980–81 season made a direct contribution to incomes in New York City of approximately $650 million, and nationally of a little over $2 billion. In 1970–71 the legitimate theater's economic impact on New York City was approximately $200 million and a little more than $500 million for the United States economy. Were these increases attributable to inflation? Increased ticket prices? Improved marketing methods? Better plays? More customers? Or still other influences?

Before I attempt to answer these questions, and to provide a frame of reference as to what happened over these last few years, there is an exciting story to tell about an industry that is an art form operating as a business—the legitimate theater. A decade ago it was suffering from malnutrition, although it still had available to it all the factors of production and potential customers to purchase its products—theater tickets. At the beginning of the 1970s the Broadway theater showed a decline after slight increases in the latter half of the 1960s. From the 1971 to the 1973 season attendance dropped from 6 million to a little over 5 million. Ticket sales dropped from $55 million to $45 million. The glamorous Broadway–Times Square theater district was deteriorating rapidly. Where retail trade establishments had previously catered to the public that came to the theater, these were being replaced by pornographic bookstores, massage parlors, and topless bars. Large movie theaters were turned into pornographic movie houses; street prostitution proliferated; street crime became rampant; the world-famous Astor Hotel was torn down; famous restau-

rants were closing—the carefree night life atmosphere disappeared and was replaced by fear. In the same way that "bad money tends to drive out good money," so the kind of population that is attracted by all the activities I have just described was replacing the theatergoing audience on Broadway.

Aggravated by the recession of the early 1970s, financing for Broadway shows declined rapidly. Neither public officials nor the general public considered this deterioration of one of the world's most famous areas and one of the world's most talked-about industries—the Broadway theater—to be of any consequence either to the economy of our city and nation or to the cultural and social values it has represented for all of us. And, further, despite all its glamour, creativity, stars, and publicity knowhow, the theater acted as if it were insulated. We created no supporters for ourselves among federal, state, and city officials to whom we could turn for assistance to preserve Times Square and the Theater. Further compounding our problem must be added the archaic operations of the industry itself. Until a few years ago, tickets were sold only at the theater box office for cash, or by a licensed ticket broker. New marketing techniques were unheard of; there were no credit cards, no checks, no telephone reservations, no outlets other than the box office and ticket brokers, and no computers. Advertising was done as always through newspapers, some magazines, and a little radio, but no television; nor was there a half-price TKTS booth (although there were some "two-fer" slips available for some shows on a limited basis). No efforts were made to attract new, younger audiences. The audience we had was growing older and gradually disappearing or, in response to all the above, was simply dropping away. That was the condition of the legitimate theater in the early part of the

1970s just before our current inflationary period—but a premature conclusion from all this is not warranted.

2. Renewal of the "Taxpaying" Theater

What has happened between then and now to have elicited the grosses I have described and to have achieved the general well-being we are now enjoying? The legitimate theater recognized that the industry had to undertake drastic measures to stimulate production; to modernize its own marketing methods; to improve the Time Square environment within which the theater lives; to secure effective support for such improvements from federal, state, and city governments; and to create conditions conducive to investment to increase the number of plays produced.

In 1972, the Shubert organization, which owned 16½ of the 36 Broadway legitimate theaters then available, changed operating heads. The League of New York Theatres and Producers under its president, Richard Barr, joined by the new Shubert officials, Gerald Schoenfeld and Bernard Jacobs, and by the other league officers, proceeded to develop a program to accomplish these purposes. Funds were raised by a very substantial monetary assessment upon all theaters and productions to support the revitalization program. We established a Special Projects Division of the league under the direction of Harvey Sabinson, a well-known theatrical publicist with many years of service in the industry. We set up a Research Division under George Wachtel, with responsibility not only for the collection of economic and marketing data pertaining to the theater but also for research that would help guide individual productions on the best ways of spending advertising dollars, which is a major cost item today.

Within a relatively few short years much has been done. Tickets can now be purchased by credit card; here resistance had to be overcome because some theaters objected to paying a commission even if it meant more ticket sales. Telephone reservations for tickets *with* credit cards finally became an established fact, and these account for a substantial part of our volume. Personal checks were accepted by the box office as payment for tickets. Previously, a personal check was accepted only with a mail order, and tickets were sent only after the checks were cleared. The Shubert organization is computerizing its method of selling and distributing tickets. It has already installed a computerized system in a number of its theaters and is gradually expanding it to all its theaters in New York and throughout the country. You will soon be able to purchase a ticket at the box office, at a remote outlet, or by telephone, and with the aid of an electronic high-speed scanner you will secure the best available seats for the performance of your choice.

The theater also revived and modernized an idea from the 1930s when you could go to the famous Leblang's ticket office on Broadway and buy an unsold ticket for half price on the day of the performance. Out of this was developed TKTS, which the Theatre Development Fund has made a reality, and which today accounts for about 9 percent of our total gross receipts. (See Table 3.3.)[1]

Our advertising is a heavily increasing cost factor. Today, television has become a very important medium (accounting for approximately 40 percent of total advertising costs), which brings our productions to the attention of a wide public. The Tony Awards on nationwide and now foreign networks has become an important part of bringing the Broadway theater to the attention of a large spectrum of people.

Table 3.3
TKTS Ticket Sales

	No. of Tickets* (000)	Total Broadway (millions)	% TKTS	$ Amount* (000)	Broadway Gross† (millions)	% TKTS
1975–76	536	7.3	7.3	3,192	$ 70.8	4.5
1976–77	810	8.8	9.2	5,509	93.4	5.9
1977–78	904	9.6	9.4	6,605	113.8	5.8
1978–79	1,260	9.6	13.1	10,958	134.0	8.2
1979–80	1,550	9.6	16.1	14,708	146.3	10.1
1980–81	1,607	11.0	14.6	17,738	197.0	9.0

SOURCE: League of New York Theatres and Producers, Inc. and *Variety*.

*Fiscal year July 1–June 30.
†Fiscal year June 1–May 31.

Tourism, especially foreign, has grown in importance. Over 2.6 million foreign visitors came to New York City in 1980, an increase of approximately 500,000 over the previous year. During the 1980–81 season, these visitors bought an estimated 900,000 theater tickets. The league became very active in the "I Love New York" campaign, contributing financially to the overseas and national promotion program and utilizing the services and international reputations of our performers in the series of commercials shown around the world.

Of equal importance is the work that has been done, and is still being done, to turn our environment around. New residential housing on Forty-second Street has been completed. Theater Row on Forty-second Street has been developed for off-off-Broadway productions. A major hotel, a $250 million investment by the Portman organization, will be built on Broadway between Forty-fifth and Forty-sixth streets. A vastly improved TKTS booth is in the planning stage, and a Forty-second Street Redevelopment Program is now being submitted for bids. It will include the restoration of several beautiful old legitimate theaters, which are cur-

rently showing "grind" movies, to their original purpose. Finally, with the help of the city, police protection and street sanitation services have improved. Street prostitution is down, and the proliferation of sex establishments has been reversed, although we still have a long way to go. But now we are getting the cooperation of city officials, who finally recognize the importance of the theater and of Times Square to the city and to the nation. These are the kinds of actions we have taken to bring us to the high level of theater activity we enjoy today.

3. Impact of Inflation

Let us see what happened to the economic components of the legitimate theater during the inflationary period that paralleled this high level of growth. Supply-side and demand-side economics have been reborn, so I will proceed along these lines and break out its various elements as it applies to the theater.

A Broadway show is put together by a general partner known as the producer. He forms a limited partnership and sells shares for investment in a production to a number of limited partners ranging from one person upward. The money he raises represents the capital or *production costs* required to open the play on Broadway. (Incidentally, when I refer to any year I mean the theatrical season ending on May 31 of that year. Also, to adjust for inflation we have used the New York area Consumer Price Index. The dollar figures I have used are averaged and may be on the conservative side.) In 1972 it required approximately $200,000 to produce a straight play. In 1981 it requires about $580,000. Adjusted for inflation, in real terms this represents a 51 percent increase *over and above* the inflation rate from

1972 to 1981. For musicals I can go back only to the 1975 season when it required $566,000 to produce an average musical as compared with $1.4 million today. Adjusted for inflation, it represents a 62 percent increase *above* the inflation rate. Because of this heavy increase in capitalization requirements, it is necessary for more producers to join forces as general partners on a single project today, and this has been an accelerating trend.

Operating costs have also shown substantial increases in real terms. In 1975 weekly operating costs for a play were about $37,000; today they are about $84,000. Adjusted for inflation, this represents a 60 percent increase *above* the inflation rate. For musicals, weekly operating costs in 1975 were about $80,000; today they are slightly above $162,000. Adjusted for inflation, this represents a 42 percent increase *above* the inflation rate.

What has happened to recoupment of invested capital, or payback? This is usually measured in terms of the number of weeks a production must run to recoup its initial investment. It is difficult to generalize with regard to these figures, since it is so dependent on the relative efficiency of the operation of a particular production. In 1972 it took about 17 weeks at capacity for a successful play and about 36 weeks for a successful musical to recoup its production costs, or capitalization; today, it takes about 25 weeks for a play and about 48 weeks for a musical. These are only approximate figures, and I believe they are on the low side.

The actual *average* ticket price in 1973 was $8.39. In 1981 it was $17.91. The 1973–81 inflation rate was 86 percent. Adjusted for inflation, the actual increase in average ticket price in 1981 comes to 15 percent above the inflation rate. Despite the large increases *above* the inflation rate of production costs and operating costs, and the increase in

the number of weeks for payback, we find that actual average ticket prices for all productions increased by only fifteen percent above the CPI inflation rate for the period from 1973 to 1981, with the largest increase occurring in the last few years; this in face of an increase in production costs of 51 percent for plays and 62 percent for musicals above inflation, and an increase in operating costs of 59 percent for plays and 42 percent for musicals above inflation.

Theatrical production is a labor-intensive industry in which it is virtually impossible to introduce extensive laborsaving devices or technological improvements to reduce costs effectively, and the increase of only 15 percent above the inflation rate for average ticket prices, very substantially below the increases in production and operating costs, is surprisingly modest. During the earlier years, 1973 to 1977, the rise in average ticket prices in real terms lagged substantially behind the CPI inflation rate. Actual ticket prices in those years increased very slowly, well behind production and operating costs increases, because producers were concerned that by raising prices they could lose the theatergoer. As a result, the theater lost substantial ground to inflation. By 1977 producers were finally forced to raise prices to partially offset costs. In effect, the period from 1977 to the present has been one in which producers have been trying to catch up with inflation and narrow the gap between prices and costs. However, they still lag substantially behind the increased production and operating costs and the payout period.

Despite the inflation, the increased costs, and the longer payback, the legitimate theater has grown *because* of the actions it has taken since 1972 to modernize its marketing techniques, improve its advertising and promotion, improve the physical environment, and encourage investment—and

these efforts have resulted in the current attendance, the highest in its history—11 million people in New York City and 16 million on the road. It warrants the reflection that we could perhaps have done even better; the heavy inflation rate through most of the 1970s may have discouraged potential productions because of the daunting capitalization requirements and operating costs. But no longer do we hear the legitimate theater referred to as "the Fabulous Invalid."

4. What Can the "Taxpaying" Theater Do Above and Beyond Our Current Actions to Maintain and Expand Our Horizons?

Since we cannot introduce cost efficiencies through laborsaving devices, it will take all our ingenuity just to try to hold costs down, especially with a new round of labor negotiations in the offing. We must investigate other areas to see if they are feasible means for expansion of the legitimate theater. One such area for exploration is the field of electronic presentation of legitimate theater—cable television, videodisks, and so on. These may help to reach wider audiences and provide additional sources of revenue. But we must also continue to expand the theater geographically, to increase the audience by increasing frequency of attendance, and to encourage an ever increasing younger audience for the future. We are optimistic!

ADDENDUM

This chapter was presented as a paper in August 1981 when the Broadway legitimate theater was at a peak of activity as reflected in the number of tickets sold and dollar grosses reported above. Since that time, attendance has declined while grosses have remained relatively constant.

Several factors may account for this decline separate and apart from the legitimate theater but that affect the economic well-being of the theater. Since 1981 we have been faced with a severe decline in the economy, both domestic and international. Unemployment is currently running at about 10 percent. A depressed international economy and a high exchange rate of the dollar against other currencies also account for a decline in tourism in New York City.

A declining economy that is reflected in public concern adversely affects theater attendance. Added to this, producers and theater owners are still faced with a continually increasing production and operating cost pattern despite the declining economy.

The Broadway legitimate theater has weathered the recent recession considerably better than anticipated. Ticket sales and grosses still show a very high level of theatrical activity, well above the low point of approximately ten years ago—the starting point of this chapter.

May 1983

On the Finances of Off-Off Broadway and Other Small Theaters

Hilda Baumol and William J. Baumol

T HIS volume is unique, if in no other respect, in the financial data it provides for both ends of the performance spectrum. Never before has so much information on the economics of superstardom been made publicly available as is provided by Joe Delaney (chapter 2). Now we turn from budgets that are astronomical to those which are minuscule and provide information on the economics of the off-off Broadway theaters, whose artistic contribution over the years has been enormous, but whose income and outlays are astonishingly small.

The Las Vegas Conference examined how all the performing arts were dealing with inflation. To discuss one of the least affluent areas we invited a representative of off-off (in this case, far-off) Broadway, Richard Reineccius, producer-manager of the tiny Julian Theatre in San Francisco. He has left to us the task of quantifying activity in this field where the average annual budget of the theaters is about $150,000 (though he provided us with a three-year budget for the Julian Theatre which is reproduced here as Table

4.8). Instead, he brought this little-known but vitally important area to life. He describes his own problems and those of his colleagues as no outsider possibly could—perceived harassment by Actors' Equity, which seeks primarily to protect its own membership in a profession where unemployment rates hover around 80 percent; the problem of attracting an audience while maintaining his artistic vision; the absence of local financial support despite national and international recognition; the desperation of the actor, working for nothing, who needs to be noticed; of nervously increasing ticket prices in a vain effort to keep up with the cost of "things we have to purchase." He then talks of the measures that have been taken by nonprofit and goverment agencies to keep such theaters alive.

To provide concrete, if pedestrian, substance to this vision, we report here what may be the only systematic survey of this segment of the theater that has even been carried out, whose results have never appeared in print before. The low-budget, nonprofit theater is an important part of American cultural life. The last systematic count of professional theaters with annual budgets of $250,000 or less identified 50 such theaters in each of the "secondary centers," California and Chicago.[1] It found 200 in New York City, and estimated that they were a part of a total of 620 small theaters located in the fifty states and Puerto Rico. This chapter discusses off-off Broadway theaters in New York City, but we believe that at least the urban theaters throughout the country have a similar profile.

This sector is open to anyone who can rent a storefront or a loft and set up some minimal equipment. Some operate under an Actors' Equity contract, and some do not; but salaries for the artistic personnel range from nothing, to carfare, to a modest weekly salary. Actors' Equity, under-

standably reluctant to allow its members to work for nothing, allows certain theaters with a maximum of 99 seats to operate under the "Showcase Code" that allows actors to volunteer their labor to stage a production but that protects their rights should the play prove remunerative.

Paradoxically, because everyone is paid little or nothing, the artistic directors can indulge in experimentation and long rehearsal periods, both prohibitively expensive in the commercial and more established nonprofit theater, and in consequence many serious and talented artists have worked in tiny theaters.

In quality they range from the barely professional to some of our cultural treasures. The "little theater" has an honorable place in the history of the American stage as the entry point and training ground for all kinds of talent and as the spawning ground of most of our leading playwrights and major innovations. At present, the movement is becoming increasingly important as a source of plays and productions and as a tryout place for Broadway, where economic constraints have virtually ruled out any form of risk taking.

To try to determine the effect of inflation on the low-budget theater, we have used 1972–73 data from an unpublished paper prepared for the Theatre Development Fund (TDF) at that time, and have made some comparisons with 1981–82 data from the files of the New York State Council on the Arts (NYSCA).

First, to anticipate criticism, it must be admitted that our sampling methods, while the best we could do, are woefully deficient. For both of the relevant years, to ensure that any theater we considered would be low budget and at least marginally professional, we used theaters that had received payments from the Theatre Development Fund for

the redemption of off-off Broadway vouchers (an innovative method of subsidizing such theaters), and that had submitted financial data to the New York State Council on the Arts. In 1972 we included budgetary data from a subset of 27 theaters—an elite group—that had been in operation for at least three years.

The highly transitory nature of off-off Broadway organizations made it impossible to get current data from the 1972 participants. Even in the elite group of our original sample of 27, 4 had graduated to off-Broadway status; 11 more are still in existence but frequently under entirely different management. The TDF list of 104 voucher payees had increased to 405, not because of increased activity, but because one of nature's laws had been at work—where funds are available potential recipients will find some way to qualify for them—and the list had widened to include individuals and performing groups that have done some theatrical work but that are not primarily theaters.

The 1972 study included 27 theater groups we interviewed in depth and 35 for which we used NYSCA data. The 1982 figures are a nonrandom sample of 32 theaters with the same general characteristics as those for which we had obtained NYSCA data in 1974.

1. Levels of Activity

Table 4.1 reports the usual measures of activity. The physical size of the theater is virtually the same as it was nine years ago, but the average number of productions and performances have decreased 32 percent and 45 percent, respectively, no doubt as a reaction to rising costs, just as has occurred in the established theater. The average ticket price

Table 4.1
Basic Indicators of Off-Off Broadway Operations

| | 1972–73 | | 1981–82 | |
	Average	Median	Average	Median
Size of House	140	100	118	100
No. of Performances	140	95	94	80
No. of Productions	9	6	5	4
Ticket Price	—	2.50	—	5.00

SOURCE: These figures were obtained by the authors for an unpublished study.

has doubled in monetary terms, leaving it pretty much what it was in 1972 in terms of dollars of constant purchasing power.

Impressionistically, there seems to be a great increase in the amount of touring, street theater, school and community center appearances, and the like that are not represented in this table. These are expensive undertakings for established theaters, but a small nonunion group can virtually transport its production in tote bags. Government sources often fund such touring operations, which reach a wide audience.

2. Finances

In 1973 reported total expenditures of the theaters ranged from $55 to well over $150,000 per year, and in 1982 from $2,500 to over $600,000 ($1,280 and $207,000, respectively, in 1972 dollars).

A few words are needed on the reasons why off-off Broadway budget figures should be interpreted with caution. It is usually impossible to assign values to hidden subsidies such as the use of a church hall, free heat, electricity, or services and volunteer labor that constitute so large a part of the operation.

In all but the most prestigious of these theaters the quality of recordkeeping ranges from none at all to first rate. At best, the job is done by a member of the company or by a small firm specializing in the arts. Add to this the propensity of the theaters to move from place to place; to take a season or a few months off for touring or rehearsing; to tear up their theaters from production to production, creating a new environment and a radically different seating capacity, and you have a statistician's nightmare.

Let us now examine the statistical tables summarizing the results of the survey to see what industry observations emerge.

As shown in Table 4.2, in 1972–73 the average theater had a yearly income of some $34,000, so that the entire set of 62 theaters had an income of $2.2 million. We calculated at the time that the overall budget for the entire set of off-off Broadway theater was under $3.5 million; the total financing of the more than 100 off-off Broadway theaters amounted to the preproduction budget for about four Broadway musicals.

Nine years later the average theater had a total annual budget of $151,400, which is the equivalent of $77,400 in 1972 dollars, an increase of 127 percent per theater in real terms, well over the rate of inflation. Yet, as we have seen, there has been a reduction in the number of productions and performances.

It is our hypothesis that many theaters whose primary concern was experimental and that served a small and special audience have foundered. As public funds dwindle, the ones that remain have had to hustle for new sources of support. It is a fact that programming of most of the remaining theaters has become increasingly conventional, and many are acutely aware of the possibility of generating

Table 4.2

Income per Theater from Selected Income Sources

(Averages for Off-Off Broadway Theaters)

	1972–73 (62 Theaters)		1981–82 (32 Theaters)			Percent Increase (1972 dollars)
	Average	Percent Of Total	Average 1981 Dollars	Average 1972 Dollars*	Percent of Total	
Earned Income	$ 16,000	47	$ 52,300	$26,700	34	66
Total Government	5,500	16	20,300	10,300	13	87
Business	26	—	10,700	5,400	6	20,800
Private Foundations	1,800	5.2	14,600	7,400	9	310
Individual Contributions	1,100	3.2	15,200	7,700	9	600
Other	9,600	28.6	38,300	20,000	29	108
Total Budget	34,000	100	151,400	77,400	100	127

SOURCE: Unpublished data and New York State Council on the Arts.

NOTE: We should like to thank Mr. Tulio Vera and the Center for Applied Economics at New York University for bringing this table up to date and doing the necessary calculations.

*Deflated by GNP implicit price deflator: 1972 = 100; 1981 = 195.5.

plays that can be sold for presentation in the commercial theater. Some of the most successful experimental theaters still survive, but inflation has changed the character of the low-budget theater movement.

Turning next to sources of income, we note from Table 4.2 that in 1972 earned income accounted for almost half the income of off-off Broadway theaters. Government sources supplied 16 percent; private foundations about 5 percent; 3 percent came from individuals; and too little came from business sources to merit mention. The picture has changed drastically in nine years of savage inflation. We see that although the theaters have managed to increase earned income by 66 percent even after converting to 1972 dollars, the great effort has failed to provide the same proportion of total support as in 1972. Thus, in 1981–82 earned income constituted 34 percent of the total budget of the average theater.

Government support also, although it has increased in monetary terms by 87 percent, now supplies only 13 percent of the total annual budget as compared with 16 percent in 1972.

The new pattern of funding has shifted the burden to private foundations, individual contributors, and business firms. Most spectacular has been the rise in business and corporate support of these theaters from virtually nothing to 6 percent of their total annual budget.

It has been argued that the actual magnitude of government contributions is a poor indicator of their actual effect and that they serve as a catalyst that encourages others by matching-fund arrangements and by serving as an evaluating agency for private sources that do not wish to pick and choose among applicants. What is obvious, however, is that the low-budget theater is getting an increasing proportion of its support from private sources, a process that calls

for continual and laborious fundraising activity. The average theater is growing larger in terms of its overall budget but is producing fewer plays and giving fewer performances.

Table 4.3 reports data on expenditures corresponding to the income figures in Table 4.2. The samples are somewhat smaller because several of the theaters that provided financial information gave no figures on outlays. Thus, the 1972–73 sample for expenditures includes three fewer theaters than that used in the outlays, while in the 1981–82 figures four theaters are missing from the expenditure calculation.

From the more recent figures we see that the outlay on personnel is the largest budget component, constituting a little more than half of the total expenses of an average theater. Rent is a distant second, contributing about 8.6 percent of total expenses. Advertising comes in third, at a little less than 7 percent of the total.

The last column of the table indicates that, in dollars of constant purchasing power, there was about a 40 percent fall in spending on purchase of equipment over the nine-year period in question. All other categories of outlay increased, even in dollars of constant purchasing power, by more than 100 percent. Personnel again took the lead, with an increase of 176 percent. Outside professional services came next, with a rise of 155 percent, and travel and transport followed close behind, with an increase of 143 percent. Rent and advertising are the relative laggards, real outlays on each of these increasing only about 100 percent.

The expenditures on personnel, incidentally, did not by any means consist exclusively of outlays on the performing artists. Some 48 percent of the 1981–82 personnel budget did go to performers, but 32 percent was devoted to admin-

Table 4.3
Expenditure per Theater by Major Categories
(Averages for Off-Off Broadway Theaters)

	1972–73 (59 Theaters)		1981–82 (28 Theaters)			
	Average	Percent Of Total	Average 1981 Dollars	Average 1972 Dollars*	Percent of Total	Percent Increase (1972 dollars)
Personnel	$ 15,300	46.2	$ 82,500	$42,200	52.6	176(%)
Outside Professional Services	1,200	3.5	6,000	3,100	3.8	155
Equipment Purchase	640	1.9	890	460	0.6	−39
Rent	3,400	10.4	13,500	6,900	8.6	103
Travel and Transport	1,100	3.3	5,200	2,700	3.3	143
Advertising	2,700	8.1	10,800	5,500	6.8	104
Remaining Operating Expenses	8,800	26.6	38,100	19,400	24.2	121
Total Expenditures	33,100	100.0	157,032	80,300	100.0	143

SOURCE: See table 4.2
NOTE: See table 4.2
*See table 4.2

istration, and 20 percent to technical and production personnel.

Several broad conclusions emerge from the expenditure data. First, outlays did rise very rapidly during the period in question. The total budget of a typical theater rose 150 percent faster than the rate of inflation during the nine-year period, if the two theater samples were in fact not very dissimilar in the variety of theaters they encompassed. It is equally remarkable that incomes were able to stay roughly abreast of the outlays.

Second, despite these increases, it is clear that the average off-off Broadway theater is a very small enterprise, with an annual budget of less than $160,000. This is, obviously, a small fraction of the budget of a major orchestra or the production cost of a Broadway play or musical.

Third, it is hardly surprising to find that labor costs are the largest single component of the budget of an off-off Broadway theater, and the one that rose most rapidly.

We do not have any recent data on compensation for performers. However, our 1972–73 survey examined these matters in some detail. The high proportion of expenditure

Table 4.4
Percent Unpaid Actors, 27 Theaters

	1971–72	1972–73	1973–74
% of Theaters with Unpaid Actors	33.1%	46.1%	42.3%
% Actors Unpaid	85.9%	79.1%	68.6%

SOURCE: Unpublished data.
NOTE: Some theaters are not represented because they had no data. Others appear twice because some of their performers were paid, others were unpaid.

on personnel (which is typical of the performing arts) may suggest erroneously that compensations of performers at the off-off Broadway theater are fairly generous. In fact, and it is still the case, a tremendous proportion of the performers are altogether upaid. Tables 4.4, 4.5, 4.6 and 4.7 present what we think is a unique study of off-off Broadway salaries. While we have no current data, we believe that the general pattern is similar today, probably with greater amounts going to administrators for fundraising.

There is no question that the main source of subsidization of the off-off Broadway theater is the actor, whose motivation is graphically described in the next chapter. We

Table 4.5
Frequency of Weekly Performers' Salaries

Dollars/Week	Number of Theaters Paying This Amount		
	1971–72	1972–73	1973–74
0	8	14	11
5	2	2	3
10	0	0	1
15	2	2	2
20	1	2	1
25	0	0	3
35	1	0	0
40	1	2	0
45	0	1	0
50	0	1	3
60	1	1	1
75	0	0	2
110	1	1	1
125	1	1	0
135	0	0	1
150	1	0	1
180	0	1	0

SOURCE: See Table 4.4.
NOTE: See Table 4.4.

Table 4.6
Salary Arrangements at Theaters Which Pay Them
(27 Off-Off Broadway Theaters)

	Median 1971–72	Median 1972–73	Median 1973–74
Actors:			
Per Week	$ 27.50	$ 40.00	$ 50.00
Directors:			
Per Production	$100.00	$ 250.00	$ 300.00
Per Season	—	$2,500.00	$2,000.00

SOURCE: See Table 4.4.
NOTE: See Table 4.4.

Table 4.7
Administrative Salaries

	1971–72	1972–73	1973–74
% Theatres Which Pay Administrative Salaries	47.6%	65.4%	73.1%
Average Salary per Year	$1,800	$4,300	$ 7,300
Median Payment per Year	$1,200	$3,000	$ 6,000
Upper Decile	$3,500	$9,000	$13,000
Lower Decile	$ 650	$1,200	$ 2,000

SOURCE: See Table 4.4.
NOTE: See Table 4.4.

Table 4.8
Financial Information
Julian Theatre 1981–83

	FY 7/1/81– 6/30/82 or CY 1981	FY 7/1/82– 6/30/83 or CY 1982	FY 7/1/83– 6/30/84 or CY 1983	Percent Change
INCOME				
Earned:				
a. Admissions, Box Office	$28,434	$38,000	$38,000	33.8
b. Subscriptions	5,424	10,000	12,000	122.2
c. Tuitions, Fees	400	1,000	1,000	150.0
d. Concessions, Rentals	3,340	10,000	10,000	—

Table 4.8—Continued

	FY 7/1/81– 6/30/82 or CY 1981	FY 7/1/82– 6/30/83 or CY 1982	FY 7/1/83– 6/30/84 or CY 1983	Percent Change
e. Fundraisers	—	3,000	5,000	203.0
f. Other (Specify):				
Touring	4,200	4,000	4,000	− 4.8
Special Commissions	2,500	3,000	5,000	100.0
Total Earned Income	44,302	63,000	75,000	69.3
Other Income (Cash Only):				
a. Individual Contributions	$ 2,428	$ 6,000	$ 8,000	233.3
b. Grants				
Hotel Tax Fund	15,070	18,200	22,000	46.6
NEA	21,200	12,500	18,500	− 12.8
CAC	12,000	14,400	15,000	25.0
Total Foundations	31,800	40,000	46,000	44.7
Total Other Income	82,498	91,100	111,000	34.5
TOTAL INCOME	126,809	154,100	185,000	45.9
Restricted Fund—Equipment	—	16,500	30,000	—
OPERATING EXPENSES				
a. Salaries (Gross)				
Administrative	$14,565	$21,000	$21,000	43.8
Artistic	54,845	60,000	72,000	31.4
Technical	8,400	9,000	17,000	102.4
Taxes, Compensation, etc.				
b. Outside Services (Specify)				
Admin/Legal & F.R. Consult	5,400	4,000	6,000	11.1
c. Production or Exhibit				
Expense	19,815	25,500	29,000	46.5
d. Space Rental	10,500	11,600	13,000	23.8
e. Office Supplies/Equipment	650	2,000	2,500	284.6
f. Travel & Transportation	782	900	1,000	28.2
g. Advertising & Promotion	13,144	15,600	20,000	52.6
h. Telephone & Utilities	1,833	2,400	2,500	36.6
i. Other (Specify)				
TOTAL OPERATING EXPENSES	129,934	153,000	185,000	42.4
SURPLUS OR (DEFICIT)	(3,132)	1,100		
Restricted Fund—Lighting Equip.	—	16,500	30,000	

SOURCE: Julian Theatre.

conclude with the budget of Reineccius's Julian Theatre for the three years 1981 to 1983. (See Table 4.8.) That budget illustrates graphically how minuscule the finances of such an enterprise are in comparison with those of, say, any commercial theater. In many ways, the behavior of the Julian Theatre budget is similar to that of the average Broadway theater. But a few items are particularly noteworthy— the not insignificant contribution of the San Francisco hotel tax, the fact that corporations have not contributed to support the Julian Theatre, and the unusual miracle of transforming a small deficit into a modest surplus in two years.

Inflation, Public Support, and the Far-Off Broadway Theater

Richard Reineccius

THE Julian Theatre has a beautiful view of San Francisco Bay,[1] and from just south of downtown we look down on the Bank of America, Transamerica, Wells Fargo, Southern Pacific Railroad, and the other skyscraper corporate headquarters in our city.

A critic for the *San Francisco Chronicle* about ten years ago, reviewing our season, called us "a model of what Far-Off Broadway should be all about." They've since transferred him to city beat, so he now chases ambulances and fire engines along with our mayor, our own "Lady Di." She does that, really. "I go to fires. I go to robberies," she said once at a candidates' night I was moderating in our theater. "You *go* to robberies?" I asked. But she does. One day she jumped from her limousine and gave mouth-to-mouth resuscitation to an old man who collapsed on the street. She jumped into a pool to save a drowning child next door to a party where she was—didn't even call the press first. Wonder Woman of the West.

But I digress, and I haven't even made a point yet. Here's

one: Bill Graham is diversifying so he doesn't have to lay off any staff. He's bought a beautiful art deco theater on Market Street; he's producing and presenting films, classical music, and live theater again (he started as manager of the San Francisco Mime Troupe, doing rock concerts as benefits to keep the troupe going). "People are hurting," he said a couple months ago to a reporter, "Instead of going to two or three things a month, they're saving up and going to one or two things every three months, and they pick sure bets." He knows. He keeps track of everybody on his computer: he also co-owns Bay Area Seating Service, the most prominent ticket agency in the area.

It was implied during this conference that for "quality" art all one has to do is raise the price of the top seats, because "people will pay anything" for the best. Well, that may be true at Carnegie Hall, and maybe Carnegie Hall doesn't need any subsidies (give them back), but it's not true on Potrero Hill, and it's not true of my friends and family in Northern California and Minnesota where I grew up. I know it's not true of audiences for far-off Broadway theaters, wherever they may be across the country, and I suspect it's not true of most people in New York.

Some of my best friends are poor people. They're poor because of inflation; they're poor because of unemployment and the technological revolution. They're poor because of temporary bad luck. They're poor because a few others are rich. (They're poor because they're children of artists—my son is here with me.)

But they deserve some fun—some of what have been loosely called "the finer things of life." "Poor people don't need art," a foundation head once said to me when we were starting the Neighborhood Arts Program in San Francisco in the 1960s. It's just the other way around: rich peo-

ple don't need art, they have all that money. For years, in Milan, people would throw red paint on those who showed up for the opening night of the opera in furs or in tails—not as a protest against the rich so much as a statement that opera had been priced out of reach of most people; not enough inexpensive seats were available. (Why do we wear tails to show opulence—and animal hair? There's a question for anthropologists.)

1. Problems of a Small Theater

I'd like to describe the current and anticipated problems of a small theater that plays to a low- to middle-income audience in a, say, typical metropolitan area outside New York, if you'll allow me to call anything in California typical. But I think some of the things I will say could apply to New York off-off Broadway theaters, to theaters in smaller cities, and so on.

What I want to do first is to give a brief profile of such a theater or such theaters in the San Francisco Bay Area; then give a little bit of reaction to what inflation, and some of the other things caused by inflation, have done to us; then I'll cover some cooperative efforts among groups that are attempting to deal with some of these problems; and, finally, I'll look at other means of support for those people who are on a shoestring—what kinds of support they can get that is not direct support.

The small nonprofit theater, as was mentioned yesterday, is subsidized by its workers very, very heavily. In San Francisco and Los Angeles we have something called the Equity Waiver rule. In New York there's a "Showcase Code." The Equity Waiver rule means that anybody operating in a house

seating 99 or less does not have to pay the actors a thing as long as the space is not nor has ever been capable of holding more than 99 people. This has a terrible built-in restriction, in that if you have a show that attracts a larger audience, and if in your space you could easily hold 50 more seats, you can't do it. But most of the theaters that exist in Los Angeles and San Francisco exist on this waiver situation.

In the San Francisco Bay Area we have two Equity companies, the Berkeley Repertory Theater, which has built a new plant in the past year with 399 seats, and the American Conservatory Theater, which is the largest nonprofit theater in the country. And the rest are either Waiver rule houses or non-Equity. The types of plays that are done are often new plays and very, very often not by writers who have worked their way through New York before "coming out." This was not true when we started sixteen years ago. Herbert Blau, codirector of the Actors' Workshop when it was still in existence in San Francisco, said: "The audience showed its appreciation for new plays by staying away in droves." It was quite true. You simply could not sell a new play. The second play we ever did was quite a hit, and it was, of all things, Euripides' *Hecuba*. We extended the run. We had audiences all the time, turning people away from a tiny, tiny church hall that held only about 70 people. So we decided that there was a fairly good play that was written by a woman I knew whose work had been done on National Educational Television (NET)—that's public television before the Public Broadcasting Service (PBS). We tried her play. It was a fairly good production. We decided to hold a limited number of performances on two weekends, two performances per weekend—and this is with a mailing list that we built up during a run of a supposedly hit show. At two of those performances no one showed up, and at the

other two we had about four to ten friends, people we had been able to call on the phone. Others simply would not go to a play that did not have a reputation. Either it had to be a classic, or it had to be something that had good notices from New York or from London.

This is absolutely true; it wasn't in the public consciousness throughout the rest of the country to go to new plays. To the credit of people—of all the actors and directors and playwrights who have subsidized the theaters in various areas since that time, and through the great help, I think, of the National Endowment for the Arts in subsidizing new plays in all geographic areas—that situation is often reversed now, to where you will have an easier time getting people, initially at least, to go to a play that is written by someone from your own region of the country and about something that is of concern in your region. And that to me is a very, very healthy situation that could not have come about without subsidy.

The types of plays being written and the people who write them can make them quite dangerous to the status quo: there is something risky about doing the new plays. And I think that we, perhaps, distrust business support for the reason that we think they're not going to support us in what we want to say. And I think businesses, in turn, distrust playwrights. They distrust theaters that do plays that are about issues, even though I think theater *must* act as a conscience for the society.

But there *is* a terrible distrust. Because the Actors' Workshop did more of Brecht's plays in this country than anyone else, and did a lot of other newish kinds of things that had a reputation for leaning toward the left, they couldn't get a dime, not a dime of business support in the fourteen years that they existed in San Francisco.

Jules Irving, codirector of the Workshop, said to me a

couple of years before he died, when he had started to get involved in live theater again after directing for Universal Television in Los Angeles: "You know, I finally asked people when we left why we couldn't get any business support for the arts." He went on, "When we got the invitation to Lincoln Center then all of a sudden everybody said, "'Oh, you're just wonderful people; why don't we have a big testimonial dinner for you and send you on your way.'"

And he said to one of the major hotel owners: "Now, dammit, why in all of these fourteen years I've been begging you, I've been on my knees, I've been trying to get you to support a production, to support a set, to support anything, why wouldn't you do it?"

And this hotel owner said, "Jules, you mean you didn't know?"

"Know what?"

"The kinds of plays you were doing—we thought you were all communists."

And I think that fear existed then, and I think it still exists. The Actors' Workshop went through two FBI investigations of all of their personnel during the time that they were there. Nothing was discovered, but it was during the "red scare" era.

Often the small nonprofit theater will be doing plays by writers who are probing issues. And that is not as easy to give money to as something else that is seen as quite safe. In fact, theater itself, I think, has a reputation for not being as clean and as "artful" as other media. For instance, a couple of weeks ago one of the development directors for American Conservatory Theater (ACT) told me she had met with the director of a foundation in San Francisco (ACT is the largest nonprofit theater in the country), and the trust director said, "Well, I like your proposal very much and I

like what you do, but," he said, "we've decided that as a trust we're only going to support the major cultural institutions. We support the ballet, we support the symphony, we support the opera." And that's to a very, very safe classical theatrical company.

2. The Small Theater's Bill of Fare

Our season this past year consisted of a new play by a German writer named Botho Strauss, who is very popular in Germany but had never been translated into the English language. He wrote a play about the new upper middle class in Germay that was very popular with our audience. It also opened in Paris right after that, was very, very popular, and will open at Joseph Papp's Public Theater sometime during this coming year. Help for that was obtained from the Goethe Institute, which is German government cultural money coming through an office in San Francisco. The institute took the risk because the amount of money needed to have a small, reputable theater company do it was so much less than that needed to mount a full-scale Broadway or off-Broadway production, to give the play and author a first chance in this country. So we commissioned the translation; the Goethe Institute brought over the original director from Hamburg to direct the play here; and we also then took it to the Berlin/Los Angeles Festival as the only American offering in that festival.

Then we did Marsha Norman's play, *Getting Out*, which is about a woman's first few hours out of prison. We then did three new plays, one by a local writer named Rick Foster based on the same Kleist novella that *Ragtime* used as its source; then one about a woman singer deciding to

leave the East Coast and go the West; and the last play was by Ed Bullins, the black playwright—a play about Joanne Little.

Other theaters in the area are very heavily into new plays. Of course, Sam Shepard lives and works in the San Francisco area, and I think again would not have become a major playwright without the help, without the production opportunities, offered by these small theaters subsidized by government funds and, of course, the actors.

There are attempts at breaking out of this 99-seat bind that groups are in. Two theaters in Los Angeles have an arrangement whereby certain plays during the year can be done as Equity productions seating more than 99, and most of the other plays can be done with 99 seats, with waiver of the rules. In other words, the actors can subsidize the theater during a period of time if the theaters will provide a certain number of Equity work weeks during the year in other shows. So they do small cast shows with an Equity contract and larger seating capacity.

The Actors' Equity office in Los Angeles has someone on staff who goes around and watches plays and counts heads. Our particular theater was taken off the Showcase, I mean the Waiver agreement, about three years ago because we don't own the space we use for productions, and the community center that does own it had some of the touring companies in from the California Arts Coucil tour. Members of Actors' Equity came and counted heads, found over 100 people, and pulled our waiver. They made an example of us, and so in the past year we've been working with limited "guest artists," or what's called the Hollywood–Bay Area Theater contract, the HAT-BAT contract. It's very expensive for us with our seating capacity. I don't think we can do it this year.

The San Francisco Foundation, which is one of the larger community trusts in the country, and which has been an important supporter of the arts, has just done a survey called ARTSFAX. It surveyed virtually all the nonprofit arts organizations in the Bay Area; got answers from some 218 of them. It discovered that one third of those 218 organizations had budgets under $25,000 and that two thirds had budgets under $100,000. Now, these are organizations that have continuing programs. And organizations with budgets between $100,000 and $2 million represented 29 percent of the respondents. The 9 largest organizations, with budgets ranging from $2 million to $14 million, represented just 4 percent of the arts organizations in the San Francisco Bay Area.

Only one out of three employees, people who are identified as employees of the companies, were paid full-time; half of the personnel were employed as artists; and volunteers outnumbered paid personnel by 3 to 1. And 25 percent of the unpaid work force volunteered in the capacity of artists. There are reasons for people doing this other than just to be with an amateur arts group. One reason is to showcase oneself so that, one hopes, agents will see you and you'll be discovered and put onto a "soap" or something. That does something weird to the performances because you often have—unless the director has a very strong hand and is a very inspirational person—a lot of people showing themselves off in the kind of the way that you see in scene study classes in college, where everybody is trying to get a good grade.

I lived in New York for some time, and considered at the end of the 1950s staying in New York and acting, and I got involved with a production at the Stella Adler Studio. I was just helping out on the technical side, because I wasn't a

student there. And they did an evening of Tennessee Williams one-acts; this was going to be the Studio's first showcase. They did an evening of Williams one-acts, six of them, which would be long enough in itself, but everybody was trying, on this first chance of their lives to showcase themselves before a set of agents and producers and so on; everybody took so much time that it was incredible. The thing lasted almost all night. There had been a preview of the thing, and about halfway through Stella Adler with her two dogs got up and announced that this was just such an atrocious event that she was calling it off, because that desperation to be seen, to get that next step, to get a paying gig, was so pitiful.

For example, if someone was instructed to walk over there to get a water pitcher, he or she would find a way of having an itch first; noticing that the curtain had fallen and going to fix that; coming over here, noticing that a tape on the floor was up, kind of smoothing that out; finding a way of lighting a cigarette on the way to have the relaxation to go over there and get the water pitcher. A piece of business that should take five seconds was elaborated sometimes into a minute, and it got completely out of hand. The director has since gone on to make a major name for himself in directing. But it just got so completely out of hand. That kind of desperate need for work does things to people.

As far as direct inflation is concerned, I think that the figures for the Broadway productions are reflected in the figures for smaller theaters. In other words, the inflation rate for things that we have to purchase and what we have to pay goes up at a much higher rate than the regular inflation rate. You can find pieces of hardware, for instance, in our scenery stock that cost 50 cents ten years ago that now may be $1.79. You will find that plywood, which you could

buy for $4.00 when we began, now costs $16.00 to $20.00. And these are just basic things that you need to put any kind of space together.

Bill Wingate of the Mark Taper Forum said that the way they cope with inflation—they figure it rises at about 20 percent per year—is that they have to keep cutting down on size of casts and keep cutting down on the number of personnel. He said their average paid company ten years ago for a play was 20 people; now it's 10. So fewer people are being employed by even a fairly rich theater company on the West Coast.

Ticket prices have gone up from the $3.00 or $3.50 that people were charging ten years ago to as high as $8.50 to $14.00 in small theaters in Los Angeles and San Francisco. Our top is $7.00. There are, of course, subscriptions and so on below that price.

I want to talk about some of the cooperation among groups hoping to help cut costs. Of course, we have regular information from such organizations as the Theatre Communications Group, which includes some of the smaller theater companies in the country and most of the major regional theaters, the nonprofit theaters. The American Arts Alliance lobbies in Washington. Each of these charges dues, so you have to pay a certain percentage of your budget to them each year for the service of getting back the advocacy programs that they are involved with, or the information on funding, and so on.

The Theatre Communications Group publishes a general monthly newsletter. It also publishes managers' bulletins and so on that are often helpful. The American Arts Alliance, which also assesses you a small percentage of your budget, of course deals mostly with Congress and with things in Washington, D.C. It does get involved at times

with advocacy at the state level, but then at the state level in California we have something called the California Confederation of the Arts, which is an individual membership organization with an elected board and a paid executive director. Lani Lattin Duke has been a very effective director for about the past three years, and has really convinced the legislature and the governor to keep the arts budget going up slightly. Now June Gutfleisch, who headed the San Diego Community Arts and was formerly from San Francisco, is taking over in that capacity.

And we have a statewide theater council that not only does advocacy on a statewide basis but does conferences and direct service—we had the conference on cable television during this past year. It also publishes *West Coast Plays,* which is now in about eight volumes, each with three or four plays in it. These are plays that were first produced or first created on the West Coast. It is an additional way of publishing the works of new playwrights— and most of them are quite important plays, we think.

On the local scene, we have Theater Communications Center of the Bay Area, which publishes a kind of actors' and technicians' *Call Board* once a month, and information for the general public. It also coordinated the information going into a recent special on five different theater companies on the local PBS station. We have Performing Arts Services, which Hugh Southern helped us to create in San Francisco, which runs the ticket voucher program and, we hope, will be running a half-price ticket booth before too long. We have our version of Volunteer Lawyers for the Arts to help artists at a low cost—it's called Bay Area Lawyers for the Arts.

We have the state Arts Council, which deals with technical services such as accounting services and whatnot, basic

help for small organizations through something called Bay Area Arts Services. They have created regional technical assistance organizations throughout the state, although it has been questioned in some areas of the state whether that money is being well spent. There are services involving accountants for the public interest. There is an organization called Support Services for the Arts that is part of the Neighborhood Arts Program. The Neighborhood Arts Program itself was created with the help of city funds and, later, National Endowment for the Arts funds. This program has been able to purchase about five different buildings around the city, basically warehouse buildings or something similar—one an old brewery, one an old shoe store, a furniture warehouse, one just an old warehouse, one an old historical opera house (vaudeville house)—and those spaces are available to artists.

And now to some means of finding space to perform. The Neighborhood Arts Program spaces are one source. Community centers and churches, of course, are something that small companies exist in. Fort Mason is an old army barracks that the army turned over to the National Park Service; and Bill Whelan, who some of you may remember got fired as head of the National Park Service, was the creator of the Golden Gate National Recreation Area. So a huge number of spaces are available within the GGNRA, as it's called.

There is an attempt to create a facility out of an old Masonic building near the Civic Center with about eight theaters, to be supported by commercial spaces, show spaces, and restaurant spaces in the same building.

We have other special kinds of support. I have mentioned the Goethe Institute that provides German cultural money coming through a local office for the western United States.

The French cultural ministry is now interested in helping to translate French works; to present them all over the United States; and, in reverse, to sponsor plays from this country in France. Other consulates have given small amounts of money.

In California we now have a liquor license law that says that any nonprofit theater that has existed for ten years or longer can buy a liquor license for $1,000, which is windfall if you've got the space, and you can serve an hour before and an hour after any performance. Some groups are doing fairly well with that. Others are clearing $20,000 to $30,000 on bingo in Los Angeles. It is a big thing. All you have to do is hold one rehearsal in a bingo palace each week, and one night of that week can be your bingo night; so if you get in on it you can make $20,000 to $30,000 a year. But you have to have some connections to get one of those nights.

A wonderful group from Colombia led by Enrique Buenaventura, a very important South American playwright, one of whose plays we did, came through. Their company, during the siestas in the afternoons in Cali, Colombia, runs a beauty shop, so all the people involved with the company do hair for two hours in the afternoon. CETA (the Comprehensive Employment and Training Act), I wanted to mention, was a tremendous boost for a short period of time and a tremendous letdown for us when it was discontinued, as it was for everybody else. And another difficulty that small arts groups are going to face (as well as large ones, I suppose) is the reduction in time covered by unemployment insurance. Many groups, expecially dance companies, had engineered this to a fine degree. They simply pay people a fairly high amount during one quarter so that once a year they can go on to unemployment and exist and work through the rest of the time.

A very useful thing would be new public sources of money to be devoted to the arts. One of the things that's often mentioned is taxing certain areas to benefit others. One of the disappointments that we had in California was that a clause was not built into the movie industry and television industry contracts that would bring something back to what we think of as the research and development arm of those industries. Those industries are always looking to the arts, and to the small arts groups in particular, as a source of materials and personnel and it's a disappointment, but that may be a possibility at some point in the future.

II
PERFORMANCE STANDARDS
and
AUDIENCE EXPECTATIONS

6

Inflation and Standards of Quality in the Performance of Music: A Personal Impression

Herbert Weissenstein

THE quality of the data and the objective analysis that have set the standards of the preceding presentations are somewhat intimidating, and I'm very grateful that my topic is purely one of personal impressions and feelings relative to standards of quality, rather than one based on complex data.

The discussion of standards of quality at this conference is an interesting one, since in the nineteenth and well into this century the problems of art were considered the province of philosophy and metaphysics, and beauty was truth unencumbered by the vicissitudes of mundane life, such as inflation, money, and so forth. This conference, and the topic of these comments, represent a change, and an examination of the performing arts that I presume would have been impossible some years ago.

My comments on this subject will be in two brief parts. First, my observation is that inflation, at least in the short

term, seems to have had very little effect on standards of quality; and the second, again brief, will reflect some concerns that are personal, speculative, and philosophical as to the possible effects of inflation on the standards of quality over the longer term. All this will be, as I mentioned, slightly unscientific. My comments are all based on my personal observations, and I will defer to others on all economic conclusions.

To set the frame of reference from which I speak and from which my impressions come, let me say that I am from New York—I work in New York; I was born in New York; and I did most of my studies and professional work in New York. I have been concerned primarily with music, particularly symphonic music, and have worked exclusively in the nonprofit sector.

1. Inflation and Standards of Quality in the Short Run

Inflation has done some very nasty things to my living costs and those of my colleagues—people in the profession, both performers and managers. But the professionals in the area, like their counterparts in other professions, seem to manage. The New York Philharmonic, and the performances that occur in Carnegie Hall, the Metropolitan Museum, Lincoln Center, and so on do represent a standard of quality in the performance of music in this country and in the world, and that standard seems very little changed over the recent inflationary years.

At these levels attendance seems to respond to popularity, not to price. Sol Hurok once said that if they don't want to come, you can't stop them, and the inverse is clearly true: if they do want to come, you also cannot stop them.

A number of marketing tests that we have run at Carnegie Hall over the last season in an attempt to guide our management decisions showed little resistance to higher prices; little resistance to the deletion of discounts; and little resistance to the deletion of incentive gimmicks such as coupon books, umbrellas, tote bags, and the rest. Similarly, contributions did not benefit when we solicited contributions with membership premiums as an incentive against solicitations purely for eleemosynary reasons.

This is confirmed by the observation at the box office that the top-priced seats sell first, and people are literally, in some cases, forced into the lower-priced seats. This is a relatively new phenomenon and, in my opinion, shows that the dollar is devalued against the expected value of the art form. The audience, I believe, perceives the value of art, as such, to be a constant. Management has been slow to perceive and very slow to respond to changing economic conditions. Mr. Cheskin has given us some documentation from the Broadway theater where prices have escalated far more quickly, and I think with far more market sensitivity than they have in the nonprofit sector. The nonprofit sector rarely tests price resistance level. The Metropolitan Opera has been the one institution to test price resistance; and sometimes, when it provides poor casts, the top tickets do indeed go beyond the point of price resistance and remain unsold. But the Met is, I believe the exception in the nonprofit sector.

We generally stick to antiquated marketing practices. It is possible, though, that this constancy in what we call a bad management practice—keeping ticket prices relatively low—might be good art and better public policy, so I would be reluctant to condemn it.

I was looking last week at Professor Baumol's book,[1]

which was published in 1966, and I would speculate that little would have to be changed to bring the observations made there up to date. The numbers have inflated, the graphs have to be extended out beyond the end of the page—but it all looks as though there has been a relatively constant economic picture in the performing arts, particularly in major institutions, which set the standards of quality.

Back to some observations. The major symphonic institutions in this country that have set the standards were founded many years ago—the Philharmonic in 1842; Boston in 1881; Chicago, Philadelphia, San Francisco, and Los Angeles all before 1919. Just recently San Francisco opened a new hall. New York rebuilt its hall in 1976. Toronto is building a new hall. In the 1960s the major symphonies extended their seasons to 52 weeks. Growth seems to continue relatively unabated. New labor contracts are concluded, and payrolls are met. Artists' fees are paid. The season has now reached 45 performance weeks; it can't grow any longer because of limitations of the calendar and vacations. Inflation seems to be all around, but I do not notice much of an impact at the standard-setting level of the performing arts.

Philip Hart noted in his book[2] that in 1970 figures the arts in the nonprofit area were just costing a mere $83 million against a gross national product of $1 trillion, and even when he added all the Broadway shows, movies, road shows, and so on, it was only $500 million against that trillion. Maybe we're just too small to be affected markedly, and maybe our audience is a group that is generally unaffected by unfavorable economic conditions and will respond to a call on their discretionary dollars. Maybe our nonprofit nature moves us out of the area of market impact on standards of quality.

To what extent can we adjust to a market, and subject to judgment in market terms? We can't improve productivity. Carnegie Hall has the same number of seats that it had when it opened ninety years ago, and the recent concert on May 5 took exactly the same amount of time as it did ninety years earlier with the one exception that our chairman of the board restrained himself from delivering an invocation as long as its predecessor, which the *New York Herald* called "tedious." But with that exception—which does not affect productivity, but merely the perceptions of the audience—we cannot respond easily to changing conditions.

Contributions make up the difference. Top ticket prices have indeed increased from $2 to $25, but these do not even constitute a truly corrected price reflecting inflationary increases that accompany ninety years of economic change. The contributions make our institutions go, and endowments give our trustees courage to take risks. Contributions continue to go up and fill the increasing gap, and the clear requirement of survival seems to attract the charitable dollar to fill that need. Prices do, indeed, increase. Endowments have generally not been as well managed as they might have been, and capital value erodes before inflation, but then we have another trick. Contributions tend to keep the endowment capital of the major institutions at a level that constitutes relatively constant purchasing power. It would be an interesting analysis to find how much of the money raised in recent endowment drives has merely replaced rather than increased capital values.

Parenthetically, as a director of development, which is a relatively recent turn in my career, I am greatly concerned with charitable contributions and endowments. These seem to me to serve to insulate the major arts institutions from normal short-term economic factors and give rise to a disturbing phenomenon. Arts institutions do not generally par-

ticipate with the nonprofit community at large in the country in seeking the kind of tax reform and modification that will yield greater contributions overall through tax incentives. The arts community virtually abstained from participation in the recent tax law change that allowed people filing short form returns to itemize charitable contributions. They tend not to realize that universities, hospitals, and social welfare charities have a much larger constituency, and we should really hang on their coattails and participate forcefully toward getting overall philanthropy in this country to run more smoothly rather than trying to deal with the arts alone.

Now inflation must constitute a black cloud, and it does in some areas. There are fewer small recital series, but then, on the other hand, there are more university arts programs. People seem to be star-obsessed: young performers occasionally get short shrift. Experimentation falls by the wayside, but overall, the standards of quality have seemed to hold in recent years. The strings of the Philadephia Orchestra and the brass of the Chicago Symphony set a standard. New players of quality have emerged through various disorderly processes—the brutality of competitions, being taken under the wing of a great teacher, and so forth. This is my view of the current situation.

2. Inflation as a Long-run Threat to Quality

And now to the second area of my comments, my philosophical worries. Performance in the nonprofit area in music has essentially four elements: the performer; the creator; the audience; and the boards of directors, trustees, and underwriters. Each of these can present problems in a prolonged inflationary period.

Virgil Thompson said some twenty-five years ago that the civically supported symphony orchestra is the most conservative institution in the Western world, and this basic conservativism seems to be increased by inflation. A long-term continuation of inflation might aggravate an increase in this conservatism. The need for broad support of the arts—by individuals, business, and government—will lead performing groups to meet the crisis of reduced funding by selecting the "safest" choices in programming rather than those that necessarily represent leadership and initiative.

The performing arts are also a social art form. Hence, the audience should always be the primary consideration.

Peter Drucker writes that inflation is a corrosive social poison, and every inflation has created class hatred and mutual distrust. He states that it is always the middle class that becomes paranoid and turns against the system, and it is that middle class that, in many ways, constitutes the bedrock of our audience. Its ability to attend performances purely in economic terms, as well as its willingness to invest the time necessary for the absorption of innovation, may well be adversely affected by protracted inflation, and represents a danger to the quality of the performing arts.

The audience is not being led forward. Though current and past standards are maintained, concern for the future and the necessary role of leadership are endangered by protracted inflation.

I have observed that a large portion of our audiences actually desire a program a little bit above their heads. For many years, Arthur Fiedler of the Boston Pops dedicated the first half of each program to a serious symphonic work, generally a young soloist playing a concerto. The audience that came to drink the Pops punch—lemonade with wine— actually was quite pleased to get a first half that was quite serious and generally above their expectations, and above

the desires perceived when they actually bought their tickets. They then got their second half that, of course, was the expected fare.

I believe the traditional audience has been developing an interest in chamber music and innovative repertoire—and certainly performers are eager to play it, particularly in view of the increasingly prevalent 52-week season. Yet major orchestras are playing more and more conservative repertoires and tend to drop innovative activities. The audience is not learning very much that is new, and music directors can very easily lose their commitment to development of an audience in any particular locale.

If we accept the observation that aesthetic taste is an acquired perception circumscribed by physical, social, economic, and psychological conditions of behavior, and that we are in a period where taste is being developed in an environment made ever more conservative because of inflation, we may conclude that we are not providing that element which will change perceptions and taste. The arts must lead and direct taste with small and judiciously applied applications of innovations. So I worry about the standards of quality in the future and the possibility that inflation may have a detrimental effect on its development.

An additional danger is that inflation aggravates the conservatism engendered by huge investments in halls, major contracts with personnel, valuable musical instruments, and increased difficulty in raising funds. I think we've become resistant to risk and are in danger of abrogating our role of leadership.

I believe administrators, trustees, the audience, composers, and performers must commit themselves to change and development. Change in aesthetic taste and judgment must be led, and not dictated by current standards of taste.

Patterns of taste change by small secretions, and must be formed by the cross-currents of many major and minor decisions and compromises every time a member of the audience attends a performance.

Standards of excellence set directions for the taste of the public. We must guard against the possibility that inflation will lead us to abrogate our responsibility to maintain the highest standards. The danger is that when the arts simply maintain themselves they are not leading and, therefore, are not representing excellence.

The New Acriticalism: Inflation in the Standards of Quality in the Performing Arts

Michael Walsh

M Y principal concern as a critic is neither the economics of the arts, which is broadly addressed elsewhere in this book and certainly that is implicit in everything I'm about to say, nor the state of music criticism. Rather, it is a liberal, even metaphysical, interpretation of the topic, "Inflation and the Standards of Quality in the Performing Arts." Herbert Weissenstein already has addressed this issue from the vantage point of one who daily must deal with inflation in its nastiest form—that is, in terms of real money. Critics, who are supposed to be beyond mundane considerations of cash, are able instead to examine what I think is a particularly dangerous form of inflation, one that is not only threatening to, but in fact already has, sapped a good deal of vitality from the performing arts, including music; namely the inflation of expectations. This kind of inflation is an offshoot of the well-known revolution of rising expectations.

Symptoms of this are clearly visible on all sides. Nothing in criticism is just "good" anymore. Everything is "great," "fantastic," "wonderful." A critic cannot write a review without saying, this is the greatest performance of Mendelssohn's Violin Concerto he's ever heard, and in fact there are some critics who have heard the greatest performance ever of Mendelssohn concerto six times in one month. When was the last time that any of us attended a concert that was not greeted by a standing ovation—perhaps not a unanimous standing ovation, but certainly one with a sizable audience participation? When was the last time any one of us heard a really bad performance (I think we have to admit, despite our liberal good intentions, the existence of evil in the world and of bad performances in the world), and when was the last time that we heard a really bad performance given its just due? When was the last time any of us here experienced the singular sensation of a genuine demonstration of disapproval, with booing and hissing and all kinds of attendant unpleasantness, outside an opera house in Italy? These days it is hard even to hear tepid applause or timorous boos at a modern music concert— even at something as ridiculous as an old-hat avant-gardist performance in which, say, a piano is dismembered by a topless woman wielding an ax onstage in the name of art. We hardly ever see people walk out of a performance anymore, as we might have two decades ago. I think this is so because present-day audiences are so intimidated, so afraid of being thought conservative reactionaries. No KGB operation could have been more effective than the one we've witnessed in the performing arts in the past twenty years—a campaign based on the pretext of excellence, or the supposition of excellence, that has systematically made people fearful of trusting their own emotions and instincts. What has happened to good old rugged individualism?

Recordings have played a great part in all this. The magic of tape, and now digital recordings, and editors with deft splicing knives have created a super race of performers that cannot make a mistake, whose every performance is note-perfect. We've become so used to hearing music on records that we demand, when we go into a concert hall, to hear every note in place. This is something that's completely new and has only happened since World War II. At no other period in musical history did anyone have even the remotest expectation of hearing all the notes. A listener wouldn't have known that every single note was in place, because he didn't have records to learn the pieces so well that he knew where every note was supposed to go. But because everyone now *does* expect note-perfect performances, we've created this race of performers who will provide us with that. But whether they will provide anything else is questionable.

What we have witnessed over the past few years has been a kind of twofold inflation as far as the audience is concerned. The first component is the real inflation of the price of a ticket caused by factors with which we are all familiar. That $5.00 ticket of just a few years ago is now that $12.50 ticket and rising. That 36-week orchestra season, up to the late 1960s, is now a 52-week season. The 55-piece orchestra is now a 90-piece orchestra or a 102-piece orchestra, with more subscription concerts to be bought by season ticket holders, more in salary and benefits to be paid by orchestra managements. In opera things are even worse—things are always worse in opera, for some reason—with a $60.00 ticket not a rarity anymore in New York and San Francisco.

The point is that patrons who have paid this kind of money want to believe that they are getting their money's worth.

Certainly this is an understandable reaction. They know that great experiences *can* be had in concert halls, and at these prices they want some of them for themselves. It's the "me" decade in action. So, if there is an unconscious, unstated conspiracy to inflate an average musical experience into a transcendental one signified by a standing ovation, who is to blame the participatory audience? It is only reacting to the prices that it paid.

It is this second component—we might call it the new indiscrimination or the new acriticalism—that is affecting the standards of quality in our concert halls and opera houses. While it is certainly worth joking about—in this connection one is reminded of Oscar Wilde's priceless remark that "Anyone who can read the death of Little Nell without laughing must have a heart of stone"—it is also serious business. If it were confined only to audiences, if it were a harmless affectation that ought to be allowed those whose pockets are being picked at every turn elsewhere, it might be less worrisome. But it has a serious impact on the work itself. The only way a performing artist has to gauge his worth is by how the audience reacts; and if audiences greet his every performance as the utterance of a great artistic truth, then what is he to think? If they greet his every appearance as the second coming of Fritz Kreisler or Josef Lhevinne, what is he to think? Of course, we all know he never reads the critics, so this is how he learns what he is supposed to think about himself.

Celebrityhood, of course, is not a new phenomenon. Quite refined ladies, after all, used to fight among themselves for the butt end of Franz Liszt's cigar or his white gloves. Today's enthusiasm, however, is caused by something different. Aside from the genuinely rare superstars—such as Vladimir Horowitz, who comes by his standing by

virtue of his talent, his personality, his famous long absence from the stage and subsequent historic return, and his sheer longevity before the public—excessive audience demonstrations for a performer generally seem to me, as a professional member of the audience, suspect. Provincial chauvinism is one side of this. San Francisco, for example, is excessively enthusiastic about anything it considers its own (it considers performers like Isaac Stern and Yehudi Menuhin its own by dint of their having been raised there) and is wildly suspicious about anyone who comes in from the outside. The critics in San Francisco seem to me to feel compelled to bear up on visiting orchestras and soloists, seeing their very presence there as part of a plot to deny the many brilliant, talented, and hitherto unheard-of San Franciscans a chance to perform with the San Francisco Symphony and Opera.

At the other end of the scale, there is the inferiority complex. When I worked in Rochester, for instance, I would sometimes get letters from people saying, "How dare you say this about Mr. X? Don't you realize that he's taken precious time out of this schedule to come all the way up here and play for us out of the goodness of his heart? We have to show him that we like him; otherwise he might not come back." The audience clearly didn't understand that Mr. X was getting a fee and that he will play anyplace that will pay his fee, whether it's in Rochester or Oshkosh or New York City. But it is obviously false to assume that the price charged is equal to the talent that is charging it. That would be like saying that Claudell Washington, who is a .279 lifetime hitter, is better than Babe Ruth because Ted Turner of the Atlanta Braves is willful enough to pay Claudell Washington $3.5 million over five years, while Ruth earned only $85,000 at the height of his career in 1930. Even adjusted for inflation, Claudell is making twice what

Babe Ruth did, but that doesn't make him a better player. Both these complexes — the superiority and the inferiority — are similar in their uncritical attitude toward the performer, independent of the performer's skill. Neither attitude is satisfactory.

The way to combat the effects of this inflation is through education. That sounds like a simplistic bit of piety: let the schools do it. We all know what shape the schools are in these days. We can't even trust them to teach our children to read, much less to think. My use of the term "education" is broader, involving all of us here today. It means performers putting themselves at the service of their art, rather than using their art for self-aggrandizement. It means critics writing the truth about performances, not what they think their readers, or their publisher's wife, or whoever, wants to hear. It means administrators hiring soloists and choosing repertoire on a sound artistic basis, keeping in mind the economic structures under which they are operating. It means, in a word, honesty. If we are honest with the public, then the public may become honest with itself.

It is ironic that the tremendous explosion in the past decade in the performing arts has not brought with it an attendant sophistication in matters cultural, generally speaking. Perhaps we should have expected it to, for the arts still are elitist in the nonpejorative sense of that much-abused term. We cannot expect people suddenly exposed to something new to become instant connoisseurs. But neither should we allow the high standards of these disciplines that we hold dear to be lowered in the name of some kind of misguided, misperceived egalitarianism. Just as it behooves us to have our unit of currency be a real dollar, an honest dollar, not 42 cents or whatever it is today, so is it mandatory that our artistic experience be genuine and that we be able to tell the counterfeit from the real.

III

INFLATION and THE ARTS

8

Economics, Inflation, and the Performing Arts

Alan Peacock*

IN their more visionary utterances the Fabian Socialists saw the arts as an important casualty of the Industrial Revolution, but, interestingly enough, those who considered their places in their ideal society believed that all that was needed to ensure their survival was the bettering of the condition of the workingman. Bernard Shaw, thinly disguised under the psuedonym of Corno di Bassetto, peppered his splendid musical criticism with references to the problem. "What we want," he argued, "is not music for the people, but bread for the people, rest for the people, immunity from robbery and scorn for the people, hope for them, enjoyment, equal respect and consideration, life and aspiration, instead of drudgery and despair. When we get that I imagine the people will make tolerable music for

*The author is grateful to colleagues at the University College of Buckingham engaged on the UCB Inflation and the Arts Project—Eddie Shoesmith and Geoffrey Millner—for information, criticism, and comments. They are not responsible for any discords that remain unresolved.

themselves, even if all Beethoven's scores perish in the interim." His fellow Socialist, Arthur Clutton Brock, in a remarkable pamphlet on *Socialism and the Arts,* was even more specific: "the conscious efforts to encourage art have not been very successful. What art wants is not the patronage of superior persons but a fair chance with the ordinary man, and that Socialism would give it, if it gave to the ordinary man a fair chance of enjoying those things which his ancestors enjoyed."[1]

This dual vision of the mass of mankind doing their own thing by way of serious cultural pursuit but unaided by government would appeal to many of us irrespective of political persuasion; indeed, it pre-echoes statements made even by those directly responsible for state support for the arts. However, the preconditions for fulfillment of the vision have long been met in major Western industrial countries, yet it is generally claimed that live performance in the arts of a serious kind may languish, and may remain the preserve of a small, well-heeled minority. "Erst das Essen dann die Kultur"—as Brecht might have said—has proved to be something of a chimera. If this were not so, this conference would not be taking place or would be concerned with very different issues.

My main theme this evening will be to examine the "techniques of survival" open to the performing arts in a difficult economic climate, but before turning to it, I think it may be useful background to consider why the prediction of cultural "progress" was falsified. I can give only the most superficial account of what the evidence shows, such as it is.[2] I suppose you could argue that the prediction implicit in the vision was that the major factor in determining attendance at live performance would be the growth in disposable income, subject perhaps to a distributional con-

straint—income distribution would not become more un-
equal but, one hopes, more equal. In fact, the growth in
attendances is positively correlated with real disposable
income changes, but the growth has not been proportion-
ate to income. Any "diffusion effect"—more widespread
attendance attributable to growing income equality, as
conventionally measured—has been absent. In technical
jargon, the dynamic demand function for attendance at live
performance is too simply specified if attention is paid only
to income and distributional factors as independent vari-
ables.

A dynamic demand function constructed by an econ-
omist would certainly have to take account of changes
through time in both the range and the prices of competing
substitutes. Although one can point to a number of new art
forms in live performances such as contemporary ballet
based on jazz and the revival of old ones such as "authen-
tic" performance of baroque music, the major competitors
have been the performance media—the radio, cinema, tele-
vision (including videocassette), and stereo and quadra-
phonic music centers.

There are two points to be made about these substitutes.
The first is that technological development has proceeded
apace, whereas such development, accepting in general
terms the famous Baumol/Bowen argument, has been large-
ly denied live performance. Technology has both improved
the quality of nonlive performance and made possible po-
tential reductions in the relative prices of these competing
substitutes after World War II.

The other point is that although these substitutes entail
investment in equipment, the investment in time per per-
formance is less, for there is no need to stir from home or—
nowadays, with transistor radios—from the beach. I am not

Table 8.1
Indices of Ticket Prices for the Performing Arts
and for "Competing Substitutes"
(1974 = 100)

	Live Theatre	Opera	Cinema	Gramophone Records and Prerecorded Tapes	Color TV	Retail Price Index
1970	56	56	63	76	—	58
1972	77	69	77	88	—	80
1974	100	100	100	100	100	100
1976	147	144	148	141	108	144
1978	194	186	189	181	127	182
1980	294	278	286	230	128	244

SOURCES: Department of Industry, *British Business,* (various issues); Central Statistical Office, *Monthly Digest of Statistics.*

NOTES: The index color TV prices is used as a surrogate for hiring charges for TV which would offer a better indicator of a competitive price movement. Unfortunately, a separate indicator for hiring charges is not available.

denying that there are other elements in live performance that continue to be appealing—the unique nature of the occasion—but whatever aesthetic judgments we make about alternative methods of consumption, the fact remains that the price of time and travel is probably a significant element in the measurement of the opportunity cost of the consumer that will determine the "mix" of purchases.

It appears that the relative prices of substitutes has risen at a much slower rate than the price of attendance at live performances, even in such countries as Australia and the U.K. where subsidies to live performance have increased in real terms, particularly during the 1960s and 1970s. Table 8.1 gives the British figures. There can be no doubt that this change in relative prices has been a major influence on attendance rates.

During the last two decades in particular, the economic position of live performance, particularly in "old" Com-

monwealth countries such as the U.K., Canada, and Australia, has been influenced, as I have suggested, not only by the box office but also by public support at all levels of government and by private and industrial patronage, which in turn are influenced by the government's view of the tax treatment of charitable contributions and of advertising. The reasons for this growth of support are complex, but there is no doubt that two decades of relatively mild inflation up to the mid-1970s coupled with positive economic growth produced buoyancy of revenues and made public authorities more receptive to demands for increased support. In the U.K., for example, the average annual expenditure in the 1960s and early 1970s on the performing arts increased at a much faster rate than either public expenditure as a whole or gross domestic product (GDP). Industrial companies became increasingly disposed toward patronizing the arts if only in order to improve their public image. They were helped, no doubt, by the tax treatment of contributions to non-profit-making concerns and also by the tax treatment of advertising expenditure.

There are certain features of public support[3] that are relevant to the later analysis of this chapter. With the notable exception of the United States, the public authorities have become the major patrons of the performing arts. Funds are very largely distributed to performing companies (as production of output subsidies) rather than to consumers or to "upstream" creators of compositions and plays, or training institutions. A large portion of the funds preserves past culture rather than promoting innovations; and, in the case of opera, the past culture of overseas countries, notably Germany, Austria, and Italy. A large proportion goes to established, often relatively large, companies of national, sometimes international, reputation that have developed the art

of ear-stroking and arm-twisting of public authorities to a fine degree.

A well-known example in the U.K. is the Royal Opera House, Covent Garden. As Table 8.3 shows, it is both a major recipient of government funds for the performing arts, even though its share fell during the period shown. These government funds represent about half of Covent Garden's current income. Tables 8.2 and 8.3 show expenditures of the Arts Council from 1970 to 1980 and grants to the Royal Opera House, respectively.

The development of the pattern of public support, therefore, has had little to do, rightly or wrongly, with the sophisticated application of the economic theory of welfare economics and, more particularly, with that element in the theory emphasizing the "public goods" problem in cultural provision. Nor does it, in my own country at least, seem to

Table 8.2
Growth of Government Spending on the Performing Arts (Arts Council Expenditure), and of Government Current Spending and of GDP (1970–80): Current Prices

	Arts Council Expenditure			Index of Government Current Spending	Index of GDP
	(£ millions)		Index		
1970	9.3	[0.17]	100	100	100
1972	13.9	[0.20]	150	113	124
1974	21.4	[0.21]	229	180	133
1976	37.2	[0.23]	399	205	244
1978	51.8	[0.26]	557	303	323
1980	70.9	[0.24]	763	444	444

SOURCES: Annual Reports of the Arts Council of Great Britain; Central Statistical Office, *National Income and Expenditure*, 1981 edition.

NOTES: The figures in brackets after Arts Council expenditure represent Arts Council expenditure as a proportion of Central Government current expenditure on goods and services.

Table 8.3
Government Financial Support for
Royal Opera House, Covent Garden, 1970–80

	Arts Council Grant (£ millions) (1)	[1] as % of Total Arts Council Expenditure (2)	[1] as % of Royal Opera House Income (3)
1970	1.42	15.3	52.0
1972	1.75	12.5	48.9
1974	2.55	11.9	52.5
1976	4.36	11.7	57.1
1978	5.31	10.3	54.5
1980	7.53	10.6	52.2

SOURCE: Annual Reports of the Royal Opera House, Covent Garden; Annual Reports of the Arts Council of Great Britain.

bear much relation to the rather vague indications given of the "objective function" (i.e., the goals) of successive governments, which inevitably leaves arts administrators in a perpetual quandary about how to formulate and execute policies. Regretfully, one must probably accept the judgment that the pattern of assistance offers strong support to the thesis that this is an instance where collective action is in the interests of the median voters who have been able to exploit their political muscle so as to be the major gainers from subsidy policy. The extension of the franchise, the growth in incomes coupled with a "fairer" distribution, better access to education and health were Fabian policies designed to transform our society—but the survival powers of bourgeois influence in our culture, represented by the performing arts, are truly remarkable! Latter-day supporters of the Fabian position, as instanced by the Committee on Culture and Education of the Council of Europe, have therefore so far called in vain for a "democratic renewal" of the performing arts, where the "full and positive involvement"

by the "people" will ensure that the correct balance of support will be promoted.[4]

1. Stagflation and the Economic Environment for the Arts

Having reviewed the recent past, characterized by mild inflation and fairly rapid economic growth, we note how expectations of rapid growth and diffusion of the performing arts have been disappointed. What, then, may happen to them if, as is generally expected, goverments continue to have difficulty in bringing inflation down below double-digit level and have to adopt monetary and fiscal policy stances that make it difficult if not impossible to encourage economic growth by increasing aggregate demand? I hasten to add that, while this kind of situation may not continue, it is a widely held view of the development of Western economies over the next decade. I shall take this view as having substance; and I only hope that the prognosticators are wrong. If you hold other views, then much of what I shall say will be even more contestable than it will appear to be already! What effect will these changes in the pace of inflation and economic growth have on the performing arts?

The standard argument put forward by performing arts representatives, and that is deployed in a plea for a greater rate of subsidy, is that costs rise at a more rapid rate than the general rate of inflation during times of rapid increases in prices.[5] Provided there is some growth in the economy, this proposition could be derived directly from "Baumol's Law," but for reasons explained later, I must add very quickly that in this respect Will Baumol would probably say "Je ne suis pas Baumoliste." If rates in the performing arts keep pace with the general rise in wage rates, costs per

unit of output will rise faster than in the manufacturing sector where the rise in wage rates can be offset, unlike the performing arts, by productivity gains. The matter is of such concern to the performing arts in the U.K. that the Arts Council commissioned two colleagues and myself to review the effect of inflation on music and drama companies. Such evidence as we may be able to provide might be used in examining the case for subsidy for particular forms of the performing arts as well as in negotiations between the Arts Council and HM Treasury—a notoriously skeptical arm of government! I shall have something to say about our results, such as they are, later on. For the moment, let it be accepted that it is at least conceivable that unless appropriate action is taken by the performing arts companies themselves, or by government and other sources of patronage, they are going to face an even more difficult economic future than other sectors.

There are a number of hidden assumptions in this argument, the one of most immediate relevance here being that the differential effect on costs would not be offset by shifts in demand curves to the right. If the rate of increase in the real income of consumers is falling and, at times, may become static or even negative, what will be the effect on the demand for the performing arts? I do not think that there is a general presumption that real income effects will be compensated by the substitution effects of falling relative prices, though I am willing to be persuaded otherwise. The performing arts face another problem—and it is an important influence in many countries. Governments, at all levels, must find it more difficult to maintain the growth in real spending if real disposable income of taxpayers is growing only slowly if at all. However, the "relative price effect," which it is claimed is operative in the performing arts, is

just as noticeable in a wide range of government services in which the government is a direct employer. The performing arts dependent on government funds are therefore faced with the problem that there are other, possibly larger and more powerful, claimants who may use the same kind of argument for differentially favorable treatment.

Rising costs coupled with demand curves that may obstinately refuse to move conveniently to the right is a situation that faces a large proportion of the modern industrial economy in periods of stagflation. What is remarkable in this situation is the extent to which the performing arts have so far managed to survive, and this is all the more remarkable given the *potentially* unfavorable differential effect that would make it more difficult for them to do so. The rest of this chapter is devoted to an examination of the techniques of survival and how effective they are likely to be.

2. The Techniques of Survival

The first technique for survival if costs per unit of output are rising faster than revenue is clearly to cut costs. The only way in which this can be done, if physical productivity gains cannot be reaped, is by a reduction in the growth of wages, on the assumption that inputs of labor per unit of output are relatively fixed and represent the major element in costs. In other words, in this extreme case the performing company has to find some way of circumventing Baumol's Law, and this would normally mean that employees would have to forgo earnings increases in line with the general growth in earnings per employed person.

The obvious example of this extreme case is the symphony orchestra in which the repertoire is limited, changes

very slowly in its content, and in which the score—as in the case of the bulk of the nineteenth-century music—dictates a total inflexibility in the on-stage factor inputs. It is precisely in this case that Baumol and Bowen and latterly Hilda and Will Baumol have made clear that the cost implications of Baumol's Law have not been demonstrated in periods of relatively rapid inflation.[6] In the latter study, it is shown that real performance outlays of United States orchestras rose more slowly than the general price level in the 1970s— a period characterized, of course, by rapid inflation. The results of our own investigations are in line with this conclusion. Whereas during the 1960s the London orchestras experienced a rise in real unit costs that exceeded the rise in any indicator of output, experience in the latter half of the 1970s when inflation accelerated and real disposable income ceased to grow, was very different. The deflated unit costs of concert promoted by the orchestras themselves, though only part of their "output," seemed to fall at a rate of about 1 percent per annum.[7]

Our investigation also supports the Baumols' view that the reason lies in a belt-tightening operation rather than in some improvement in productivity, achieved, say, by reducing the size of symphony orchestras. However, I don't think that Will Baumol makes sufficient use of his own analysis of the cost disease in order to explain why the belt-tightening operation has been accepted by labor unions that are strongly extrenched in the performing arts. Unions typically try to maintain their relative position in the wage hierarchy—at least in the U.K.—and will fight hard against cuts in the real wage rate, even if it means that employers will shed labor as a method of cost control. For any given level of output with labor input per unit of output fixed, shedding of labor is impossbile if *any* output is to be pro-

duced. Firing the last two desks of all string sections and the fourth member of every woodwind and brass section destroys the product.

The British orchestral case is interesting. Wages and salaries account for about 60 percent of total costs in the London orchestras and rather less in the case of regional orchestras. Between 1972 and 1981 wage costs increased by about 14 percent per annum and 12 percent per annum in the London and regional orchestras, respectively, and this compared with an annual average rise in earnings in production industries of more than 16 percent over the same period. This result was achieved partly by a reduction in the rate of increase in players' fees relative to wage rates in skilled employments and interestingly enough, partly by a reduction in the ratio of rehearsal time to performance time, though this was a much less significant factor.[8]

Symphony orchestras tied to inflexible repertoires dominated by nineteenth-century music are extreme though important cases. One of the most interesting changes in the field of music has been the growth of demand for baroque and earlier music stimulated by the enthusiasm as well as the skill of mainly younger musicians. The rediscovered repertoire is enormous and still growing. The factor "mix" and the quantity of "onstage" factor inputs can be varied in the sense that the same parts may be played by different instruments, and the size of the total onstage labor input is not specified by the composer. Indeed, the emphasis on performance "authenticity," even in the case of Mozart symphonies, has been coupled with the artistic recommendation that orchestras should be smaller in size. Therefore, in difficult times, substitutions in the repertoire or additions to the repertoire may be made that permit shedding of labor without a perceived decline in the quality of output.[9]

Even if the factor mix and the amount of labor input is significant and fixed, it is still possible for productivity gains to be reaped in order to offset rising costs associated with inflation. This is made possible if the repertoire changes through time so that a large part of it at any moment in time represents new products. The selection of new products can then be conditioned by the insistence of managment that the "cast" is kept to the minimum consistent with the attraction of the end product. Thus, the large bulk of plays and musicals in the contemporary theater are almost certainly new creations in contrast to the orchestral and chamber music repertoire, and I suspect that over time there has been a marked diminution in the size of casts and in the degree of elaborateness of sets. Even classical production requiring huge casts may allow the possibility of doubling not only the "spear-carrying" parts but even major parts.[10] It was claimed in a recent production of *A Midsummer Night's Dream* that if the same actor plays Theseus and Oberon and the same actress Hippolyta and Titania, the dramatic significance of the play is enhanced—it may also be a useful way of cutting costs unless the players get double pay! However, now that we have reached the apogee of cost cutting in one-man shows, it may be difficult to envisage further reductions in labor input per unit of ourput as a method of survival in a slow-growth, high-inflation era.

The second technique of survival may be loosely termed "marketing strategy," and has several dimensions. Astute managers of performing arts organizations are likely to be constantly engaged in appraising the nature of the "package" that attracts audiences in differing circumstances. In understanding the problems facing them in times of stagflation, there is much to be said for adopting a Beckerian stand,[11] by which I mean that one should consider the household as a producer in which the relevant output is

some sort of aesthetic pleasure and the inputs in the household production function are a whole range of cultural goods ranging from concerts, theater, opera, and ballet through to art galleries and even gourmet meals. The efficient use of these inputs by the household also requires complementary investment in knowledge of their cultural underpinnings in the form of, say, a knowledge of cultural history, ability to read a score, to play an instrument, to paint, and so on. There may be considerable "spillovers" in studying one art form in respect of its bearing on the understanding of another, particularly where the art forms may be "merged," as in opera and music theater. In the case of live performance inputs, the complementary input of time is important.

Let us assume that marketing strategy is directed toward the retention of *existing* audiences. As a broad generalization, this means directing attention to the cultural tastes and preferences primarily of an educated relatively prosperous minority, largely, though certainly not exclusively, in working age groups. In this case, the "representative" household is maximizing aesthetic enjoyment subject to more restrictive budget constraints than hitherto, given the slowing down in the growth of real income, but with the value of time still high relative to lower-income and other age groups. Moreover, technological improvements are proceeding apace that are reducing the relative price of "canned" performance and improving its quality. What marketing strategy should be adopted?

The argument suggests that the general strategy should be to design cultural "package deals" that combine or juxtapose several cultural experiences. Examples range from running chamber concerts in historic mansions, perhaps coupled with a gourmet meal, to carefully orchestrated

package deal holidays sponsored by performing arts organizations in association with travel agents and municipal authorities. The consumer then has to weigh the benefits of reducing the time and travel costs of cultural consumption against the possibility of cultural indigestion! This kind of marketing has been going on for a very long time, the most famous example being perhaps Wagner's attempt over 100 years ago to lure the elite of the world to Bayreuth by a combination of music, myth, drama, and ambience and to maintain brand loyalty[12] by following the *Ring* with *Parsifal*. It would be interesting to see how far it will grow as a marketing strategy in difficult times.

The cultural complex concept, however, takes considerable organization, as indeed Wagner himself found, and different performing arts companies, which are actual or potential rivals, may not be willing to incur the costs of bargaining involved if the perceived gains are uncertain and small. What they can agree about is that mileage can be made out of the argument that a cultural complex confers unconvenanted benefits on urban communities anxious to attract industry and create job opportunities through improvements in what is vaguely termed "the quality of life." This argument has grown in dimension in the last ten years and has received a good deal of support from urban economists, but it is not my purpose in this contribution to evaluate it, which I have done briefly elsewhere.[13] In the present context, I simply offer the speculation that in periods of stagflation, when government support at all levels may be circumscribed by the factors already depicted, it may be that the arguments for support based on economic impact of the arts are likely to be deployed more intensively. I know this to be true of the United States, and it is becoming true of the U.K. where it is claimed that the arts

offer an economic contribution to the balance of payments far beyond their direct foreign exchange earnings.[14] This aspect of marketing strategy recognizes that that survival depends on the deployment of more down-to-earth arguments—possibly garnished with more sophisticated economic analysis—and also the more intensive use of cultural pressure groups.

Marketing strategy in difficult times requires something more than reliance on retaining the loyalty of the educated and well heeled. The performing arts will be forced to move "down market," and in the U.K. and other European countries are already doing so, and quickly. I hasten to add that I do not mean by this observation that orchestras, opera companies, theaters, and so on have not invested before now in audience search by discriminatory pricing, designed, for example, to attract younger age groups and a wider range of social classes. This is a well-known strategy. This strategy, too, has often been characterized by concentration on the more popular classical repertoire and by the employment of principals who may be national or international figures well known on, say, television. I mean a more deliberate move towards exploiting more popular art forms.

The example I know best concerns recent changes in the orchestra world in the U.K. and the Netherlands. In the U.K. the professional musicians who are members of large orchestras are frequently employed in ad hoc ensembles hired by the so-called fixer to provide down market entertainment ranging from light music concerts (the Strauss family, Lehár, plus the *1812 Overture!*) to heavy orchestral backing for pop stars in lavish TV productions. Orchestra managements somewhat resent the fact that these profitable arrangements, while benefiting their own moonlighting musicians, leave them with the unprofitable activities.

The more intensive use of the orchestra could both retain the overall earning power of its members and help to cross-subsidize the "serious" side of their business. When the Royal Philharmonic Orchestra manages to perform a piece that reaches the Top 20 of the hit parade and, along with other orchestras, attempts to emulate the Boston Pops, and when in Holland the Utrecht Philharmonic makes a killing by mixed repertoire concerts with pop groups we know that we are entering a new era in market adjustment in the performing arts!

The third technique of survival recognizes that the economic relations between the performing arts and rival methods of production, and between them and the creators of artistic works, are complicated and often difficult. They are likely to be even more so in a period of stagflation when survival depends on cutting costs and on seeking new sources of finance. There is a particular aspect of these economic relations that is becoming of major importance to the performing arts, namely the determination of property rights in performance. Let me again take musical performance, including opera and ballet, as an example. On the cost side, there is a clear incentive in periods of financial stringency to economize on copyright works, and this means discrimination against modern music and particularly music by living composers. Performance right costs are not normally a large part of variable costs of performance, but recent attempts by music publishers to see larger royalties for composers whose work is still in copyright (and this still includes works by Holst, Elgar, and Delius [until 1984!] as well as Bartók and Stravinsky), coupled with the lack of audience attraction of many such works, even when sandwiched between the classical repertoire, have been encountering stiff resistance. On the revenue

side, the fear that improvements in gramophone and broad-casting performance, coupled with the growth in video-cassette sales and cable television services, has alerted orchestra management to the need to redouble their efforts to claim more extensive property rights in canned perform-ance and to restrict the use of canned performance on ra-dio and television. I would not wish to predict the outcome of this sharpening of the conflict over performing rights. It may be settled within the existing laws of coyright and by recourse to arbitration procedures accepted by the parties concerned, but I would hazard a guess that governments may become increasingly involved in such issues, though probably within a much wider context than the performing arts alone.

3. Concluding Remarks

In a footnote to his well-known article, "What's Wrong with the Arts Is What's Wrong with Society."[15] Tibor Scitov-sky makes a very kind reference to me as a victim of the conflict between the economist conducting a critical exam-ination of the arguments for government support for the arts and the amateur musician who has a strong vested interest in a flourishing performing arts sector. Another dimension of this conflict is presented by this move away from my earlier normative analysis to this attempt at a positive anal-ysis of trends in the economic condition of the performing arts.

I do not doubt that in the more hostile climate encoun-tered in a period of stagflation, or at least of slow economic growth, performing arts companies of established reputa-

tion with well-maintained means of communication with government have every prospect of survival. Indeed, the fact that their survival is less assured than it was will improve their sensitivity to market forces and will make them more conscious of the need to justify their demands for continuing public support by the use of more cohesive argument and greater willingness to be subject to closer empirical investigation. The disturbing feature—if I may drop my economist's mask for a moment—of the foreseeable future is the more formidable economic problems encountered by both new entrants to the business of performance anxious to exploit new ideas in presentation and in repertoire and their natural allies, the creators of new plays, operas, orchestra compositions, and ballets. For the former, the risks of failure are greater and the access to sponsorship from private or public sponsorship made more difficult by increasing competition for funds.[16] For the latter, the odds on obtaining performance by established companies already playing it safe and moving down market appear to be lengthening. I am not going so far as to argue that while the preservation of cultural heritage may be secure its development will be stunted by economic circumstances. Symphonies, operas, and plays will continue to be written embodying new techniques of expression, even if they remain unperformed publicly. The creative artist has often had a rough time of it in fighting for recognition, but the worrying feature of lack of opportunity for performance lies in the possibility that he or she may simply prefer to give up the struggle. In recent years composers of music and opera have often claimed that they are engaged in pure research in acoustics and have no inclination to market their wares.[17] To encourage them further in this belief would

be to risk severing the all-important links between the creative artist and the public upon which cultural evolution must surely depend. Nothing concerning the position of the performing arts in a period of stagflation would give me greater pleasure than to have this speculation about their future falsified by events.

9

The Economy and the Performing Arts

Russell Sheldon

THE data on consumer prices and the prices of entertainment services make it obvious that over the last few years entertainment services have increasingly become a bargain. During the 1970s the rate of ticket price inflation was about 5 percent in the entertainment field and nearly 8 percent per year as measured by the overall Consumer Price Index (Table 9.1). It is clear that supply and demand have been at work in this industry. In general, when a particular price increases at a much slower rate than prices generally, one expects people to buy more of that particular good or service and less of other things. Figure 9.1 uses data that the American Symphony Orchestra League (ASOL) collects for all symphony orchestras in the United States and Canada and stores in a central data base. It is very useful in helping individual symphonies follow what is happening in national trends and helps them plan their own activities and their own pricing behavior on the basis of what other people have done. The data they collected for 1974 to 1979 indicate that the average growth in subscrip-

Table 9.1
Consumer Price Indices
(1967 = 100)

Year	Total	Entertainment Services
1970	116.3	121.0
1971	121.3	127.4
1972	125.3	130.7
1973	133.1	134.9
1974	147.7	143.2
1975	161.2	152.4
1976	170.5	159.0
1977	181.5	166.2
1978	195.4	175.4
1979	217.4	187.6
1980	246.8	201.6
Average Annual Increase (%)	7.8	5.2

SOURCE: Department of Labor, Bureau of Labor Statistics.

tion ticket income was 11.5 percent. But most of that increase represents a rise in the number of tickets sold. The symphonies managed to increase the number of seats 6 percent per year, and that means that the rate of inflation in symphony ticket prices was only 5.3 percent during the 1974 to 1979 period. The lower rate of price increases has produced a steady real gain in attendance at symphony orchestra performances. That is about the same as what we see happening in the entertainment services field generally and is well below what has happened to CPI.

In fact, increased attendance has occurred throughout the entire legitimate theater and opera industry of which the symphony orchestras are a part. There was a slowdown in attendance in this industry between 1970 and 1973 that clearly showed up in the national data (Table 9.2). Column

Figure 9.1
Selected Major Orchestras: Relative Demand vs. Ticket Prices*

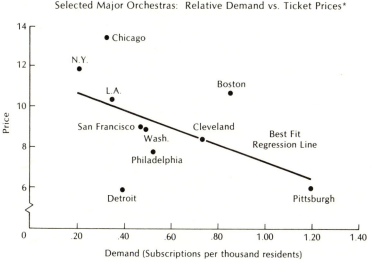

*Actual prices and demands for major orchestras.

SOURCE: American Symphony Orchestra League, Annual Reports.

3, which measures expenditure on legitimate theater and opera in real terms, shows no increase at all between 1970 and 1973, and a recession of sorts in 1971 and 1972. But since then things have been booming, and the growth rate of outlays on legitimate theater and opera exceeded 5 percent over the entire decade of the 1970s. By way of comparison, that is about as fast as the Japanese economy grows and, of course, much faster than the growth experienced by the United States economy as a whole during the last decade.

Column 4 of Table 9.2 shows a significant increase in the share of total consumer spending allocated to legitimate theater and opera performances during the last seven or

Table 9.2
Legitimate Theater and Opera Expenditures

Year	Millions of Dollars	Millions of 1972 Dollars	Share of 1972 Dollars Total Expenditures (%)
1970	$501	$541	0.080
1971	495	506	0.073
1972	529	529	0.072
1973	561	542	0.071
1974	613	557	0.073
1975	667	563	0.072
1976	777	636	0.077
1977	868	692	0.080
1978	1064	807	0.089
1979	1230	863	0.093
1980	1318	872	0.093
Average Annual Increase (%)	10.2	4.9	

SOURCE: Survey of Current Business.

eight years. Spending increased steadily from a low of 0.07 percent of overall consumer outlays in 1973 to more than 0.09 percent in 1980. The rate of inflation in the legitimate theater and opera industry was 5.3 during these years, again about the same as the increase in entertainment services prices but much less than the average inflation rate for the economy as a whole.

The relatively low rate of price increase has played a large role in the industry's ability to sustain a growth rate well above the national trend. Ticket prices have been kept in line even though production costs have been soaring. Travel costs, to mention just one example, are very important in the entertainment industry, and have been increasing much faster than have ticket prices. In 1980 airline fares went up 38 percent, and it looks as though they may be going up again, since the scarcity of air traffic controllers is

likely to reduce the number of flights over the next three years. Meanwhile, lodging expenses have been going up at rates well into the double digits—about 15 percent on average—during the last three years, and the same sort of increases have occurred in the cost of food away from home.

As far as wage costs go, the best information available again comes from the symphony orchestra's data bank. Table 9.3 shows what has happened to symphony salaries, and again some explanation is needed. Symphony salaries increased at an annual rate of about 8.5 percent during the last half of the 1970s. However, bearing in mind that the symphonies have been averaging a 6 percent growth in attendance, wage costs per ticket sold have gone up at only a 2.5 percent rate. Thus, we can conclude that one of the reasons why ticket prices have increased only moderately has been the absence of a rapid increase in labor costs on a per ticket basis. In Table 9.3 symphony salaries are presented in real terms. I have used the personal consumption

Table 9.3
Symphony Salaries

	Avg. Weekly	Percent Inc.	Minimum Weekly	Percent Inc.	Real Avg. Weekly*	Real Minimum Weekly*	Ratio Avg. Symphony to Avg. Prod. Worker Sal.
1974–75	$308	—	$271	—	$255	$224	1.76
1975–76	327	6.2	294	8.5	254	229	1.74
1976–77	362	10.7	319	8.5	267	235	1.79
1977–78	391	8.0	347	8.8	271	240	1.79
1978–79	424	8.4	374	7.8	272	240	1.79
1979–80	466	9.9	408	9.1	273	239	1.82
Average Annual Increase (%)	8.6		8.5		1.4	1.3	

SOURCE: American Symphony Orchestra League, Annual Reports.
* *Deflated by the implicit price deflator for personal consumption expenditures.*

expenditures deflator, which rises more slowly than the CPI because it takes account of the savings permitted by substitution from products whose prices rise rapidly toward items whose prices rise more slowly. Table 9.3 shows that the real incomes of symphony orchestra performers have been increasing over the last six years and that the relative incomes of symphony performers have improved considerably when compared with the wages of production workers in the private nonfarm economy. The key to all this, of course, has been the symphony's ability to keep real growth in attendance on a rapidly rising track during the last few years.

Table 9.3 shows average weekly salaries in both monetary and real terms. Despite a large increase in 1976–77 following the 1974–75 recession, salaries have been increasing at a rate ranging from 8 to 10 percent. The minimum weekly wage reached $408 in the 1979–80 season and will probably go up at least 9 to 10 percent in 1980–81 to about $450, which is an annual wage of $20,000 to $25,000 for most members of symphony orchestras. Table 9.3 shows that, in real terms, the largest increase again occurred in 1976–77, when there was a big increase in nominal salaries but not much inflation. After the recession of 1974–75, two years of fairly low inflation rates and a large increase in nominal salaries produced large increases in real wages in that year. Since then they have remained fairly stable. Most of that gain, in other words, occurred early in the last recovery period, and when inflation heated up toward the end, the rate of increase in real wages slowed down. However, a 1.4 percent increase in average weekly wages, low as it sounds, is better than the economy was doing. With little productivity increase in the last half of the 1970s, the ratio of average symphony to average

Figure 9.2
Selected Major Orchestras
Average Salaries*

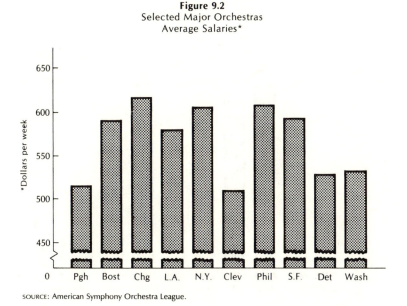

SOURCE: American Symphony Orchestra League.

production worker salaries reached a low of 1.74. This means that symphony employees on aveage had 75 percent higher salaries than production workers in 1975, and there is now a gap of 80 percent between symphony employees and average production workers.

Figures 9.2 and 9.3 provide incidental information showing differences in monetary and real average salaries for a sample of major orchestras. (The data in Figure 9.3 are adjusted for differences in cost of living in the orchestra's home city.)

As a prelude to a discussion of philanthrophy, let me tell you, if I may, some of David Stockman's views on the arts. He believes that for too long the endowments have spread

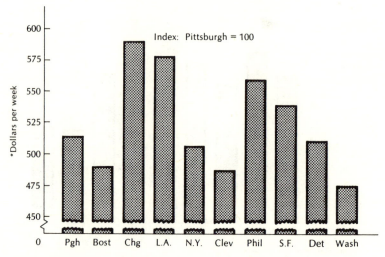

Figure 9.3
Selected Major Orchestras:
Salaries with Cost of Living Adjustment*

SOURCE: American Symphony Orchestra League.

Federal financing into an ever wider range of artistic and literary endeavor, and have promoted the notion that the Federal government should be the financial patron of first resort for both individuals and institutions engaged in artistic and literary pursuits

I am told that, while the Stockman plan called for $88 million in budget authority for 1982, the Senate version of the spending bill is about $120 million and the House bill is much higher than that, close to $160 million, which would represent no reduction at all in funding.

In view of the federal budget cuts, there is great concern about what is happening to private philanthropy, because this already important source of funding for the arts and hu-

manities promises to become more so in the future. There has been a considerable increase in total private philanthropy over the last decade, as shown by the first line of Table 9.4, which indicates that funds have more than doubled during that time period. However, this increase was largely ascribable to inflation. One might expect, all other things being the same, that philanthropy would keep up with GNP growth, since living standards are rising in real terms; one might think that it would even grow faster. Adding to that, we had a highly inflationary economy that was pushing people into higher and higher tax brackets all during the 1970s, and since giving is a tax deduction one would have thought that that particular factor would have spurred additional giving, but it really has not happened. Viewed as a percentage of GNP, philanthropy has been on the decline. Table 9.4 shows clearly the severity of the downward trend in the share of philanthropy, or the ratio of philanthropy to total GNP. For most types of giving, the troubled and turbulent economy during the 1970s, and particularly the high inflation rate, served to reduce private philanthropy. But there was an exception, and that was funds allocated to the arts and humanities. The share of total philanthropy going to arts and humanities grew from about 3 percent to more than 6 percent during the last ten years. And this increase proved sufficient to fund much of the growth in activity that occurred over the last decade. Some new 1980 data suggest that the downward trend in total philanthropy seems to have ended in 1980 and that we have been in a flat pattern. It is possible that the economic conditions during the last half of the 1970s that produced the environment that reduced giving are being reversed.

It is dramatic that the arts and humanities were able to increase their percentage and total share of funds received

Table 9.4
Private Philanthropy
(Billions of Dollars)

	1970	1975	1976	1977	1978	1979	1980e	1985e	1970–79 Annual Avg. Growth (%)	1975–85 Annual Avg. Growth (%)
Total Funds	20.7	29.7	32.5	36.0	40.1	43.3	46.0	84.3	8.5	11.7
Share of GNP (%)	2.09	1.92	1.89	1.88	1.86	1.79	1.75	1.80	—	—
Individuals	15.9	24.2	26.6	29.3	32.8	36.5	—	—	9.7	—
Corporations	0.8	1.2	1.5	1.7	2.1	2.3	—	—	12.5	—
Bequests	2.1	2.2	2.4	3.0	2.6	2.2	—	—	0.5	—
Foundations	1.9	2.0	2.1	2.0	2.6	2.2	—	—	1.6	—
Funds Allocated to Arts and Humanities	0.6	1.7	2.3	2.3	2.5	2.7	2.9	5.2	18.2	11.7
*Share of Total Funds (%)	2.9	5.7	7.1	6.4	6.2	6.2	6.2	6.2	—	—
*Real Funds Allocated to Arts and Humanities									10.9	2.0

SOURCE: American Association of Fund-Raising Counsel, Inc.; 1980–85 estimated by Mellon Bank.
*Deflated by the implicit price deflator for gross national product.

even though the national trend was down for most phil-
anthropic sources. We believe that we have already seen
this trend leveling out and that it will continue.

Throwing these observations together, I will venture the
following five-year forecast. Assuming that the share of
GNP that goes to philanthropy stays constant—and I think
that is a fairly reasonable premise—total philanthropy will
probably go up at a rate of nearly 12 percent between 1979
and 1985. If the funds allocated to arts and humanities go
up at about the same rate as well, one gets a 12 percent
increase in funds allocated there, *before correction for
inflation*. In real terms, that is, in constant dollars, this
amounts to an annual growth rate of about 2 percent.

How does this compare with the previous record? Look-
ing in Table 9.4 at the column reporting 1970–79 annual
average growth, one sees that the real increase—that is,
after inflation—on an annual basis was almost 11 percent in
the arts and humanities, a much higher rate of growth than
that in general economic activity. This has probably fi-
nanced lower ticket prices in some of the arts even though
costs were increasing at a faster rate.

Projecting into the future, it is hard to foresee the same
sort of improvement as in the 1970 to 1979 period. There is
no reason to expect that arts and humanities will increase
their share of total funds, and without that we cannot ex-
pect that 11 percent real growth rate to continue. However,
even a 2 percent rate of growth after inflation represents a
steady improvement in the total purchasing power available
to the arts and humanities.

Summing up, the legitimate theater and entertainment
services did very well in terms of growth in attendance
during the decade of the 1970s, even though most indus-
tries were suffering. The main reason may well have been

moderation in ticket prices. One way or another, by keeping costs to the public down, the performing arts were able to bring attendance up and actually to increase attendance dramatically during the decade.

The period ahead is likely to require a struggle to retain the gains of the last few years. It is.difficult to keep prices going up at a rate slower than general inflation for a long period of time. Meanwhile, the beneficial effects of very rapid growth in philanthropy are unlikely to continue in the next few years, and that will increase the pressure to pass through cost increases in the form of higher prices. And, of course, if that does happen, then a slower rate of growth in attendance can be expected during the next four or five years.

Observations about Inflation and the Performing Artist

Harold Horowitz and
Thomas F. Bradshaw

NEVADA is one of the leading states in the nation in the performing arts. We see that very clearly in the data the Research Division* at the National Endowment for the Arts has collected on the American performing artists.

Table 10.1 shows some calculations we have made using data from the 1970 census on the proportion of employed dancers, actors, and musicians in the total labor force of the states of Nevada, New York, and California. It may not come as a surprise to you, although I know that it does surprise many on the East Coast, that Nevada was the top-ranking state in the 1970 census in having the greatest proportion of employed performing artists in its total work force. The two states usually thought of as being the leaders are New York and California. New York, however, ranked fourth and California ranked third. (The second-ranking state is not on the table. Can you guess? It is Hawaii.)

In 1970 one had twelve times as great a chance of meeting a dancer in Nevada's total labor force as one did in the

Table 10.1
Proportion of Employed Performing Artists
Among the States' Total Workers
Compared with the U.S. Average, 1970

	Nevada	New York	California
Dancers	1,256%	159%	237%
National Ranking	1	8	5
Actors	175%	358%	293%
National Ranking	4	1	2
Musicians	366%	128%	140%
National Ranking	1	6	3
Total Performing Artists	400%	152%	160%
National Ranking	1	4	3

SOURCE: Tables 24, 27 and 29, NEA Research Division Report No. 5, *Where Artists Live: 1970.*

average state; but it is really the musicians that tipped the scale to give it top ranking, because they are so much more numerous an occupational group than either dancers or actors.

We wish that it were possible to give you rankings for the 1980 census, but the data are still not available to us. It's a guess at this time, but our judgement is that Nevada will retain its first-rank position when we do see the 1980 data.

The ranking, based on the proportion of employed performing artists in each state's total work force, is an interesting approach to making some adjustment for the vast difference in population among the several states. Table 10.2 views the problem from a different perspective. Nevada had only 1 percent of the total 1970 national population of employed dancers, actors, and musicians, compared with 14 percent for New York and nearly 16 percent for California.

Table 10.2
Employed Performing Artists, 1970

	United States	Nevada	New York	California
Dancers	5,950	194	889	1,390
Actors	9,728	44	3,246	2,790
Musicians	87,834	830	10,460	11,991
	103,512	1,068	14,595	16,171
	(100%)	(1.0%)	(14.1%)	(15.6%)

SOURCE: Tables 13, 16 and 18, NEA Research Division Report No. 5, *Where Artist Live: 1970.*

Our opportunities to study organizations in the performing arts in Nevada have been much more limited than those for the study of artists in other states, because most of Nevada's activities are by establishments that are taxable and, therefore, outside the usual area of interest of the National Endowment for the Arts. If the 1977 Census of Service Industries is reasonably accurate, then Nevada also has a unique position among all states in terms of its ratio of taxable to tax-exempt establishments in the performing arts. Of the total of 132 establishments enumerated in the 1977 census, 129 were taxable and 3 were tax exempt. No other state approaches that ratio. For the United States as a whole, 7,896 performing arts establishments were counted —6,721 taxable and 1,175 tax exempt. That is roughly 6 to 1 for the United States; but the ratio is 43 to 1 for Nevada. The 1977 census classified establishments by their primary function. Establishments that are primarily something else and only secondarily involved in performing arts are not counted in either the national or the Nevada figures. Our guess is that this tends to increase further the difference between the ratio of taxable to tax-exempt activity in Nevada and the country as a whole.

1. The National Endowment for the Arts

It may be helpful to give some information about the Research Division and the National Endowment for the Arts to explain the context in which our work is done. The NEA is one of the independent agencies of the federal government. It was established in 1965, and received its first appropriation of $2.5 million for programs for fiscal year 1966. Since then, its appropriations for programs have grown to over $150 million. Fiscal year 1981, which ended on September 30 of that year, is still uncertain because a recision action is pending, and it will be some weeks before we know the outcome. If you have been following the news reports, you are aware that our budget for FY 1982 is still in question, and is likely to be lower than in FY 1981.[1]

The NEA's legislative mandate limits the agency to the support of individuals and of organizations that have tax-exempt status, 501(C)–3. The broad goal of the NEA is to foster the professional excellence of the arts in America; to nurture and sustain them; and, equally, to help create a climate in which they may flourish so that they may be experienced and enjoyed by the widest possible public.

The Research Division is a service unit, not one of the NEA's programs. The programs are: Dance, Design Arts, Expansion Arts, Folk Arts, Literature, Media Arts, Museums, Music, Opera Musical Theater, Theater, Visual Arts, and so on. The programs are the operating units of the agency that provide support to the arts fields and constituencies. The Research Division is an internal unit that collects and analyzes policy-related information and serves in a support role.

Members of the university research community who may be present at this conference will be interested, though not

necessarily pleased, that the Research Division does not encourage unsolicited proposals. Nearly all the projects of the Research Division are carried out either by its own staff or by a grantee or contractor who has received a competitive award as a result of a program solicitation that was first widely advertised in such federal procurement media as *Commerce Business Daily*.

The Research Division was organized late in FY 1975 and made its first competitive awards in FY 1976. The total funds available each year for externally conducted research projects have been approximately 0.5 percent of the NEA's program budget. With these limited resources, the Research Division has set in motion a program covering several major subject areas: the nonprofit arts and cultural organizations, the artist population, audiences and audience demand for the arts and cultural services, and state and local funding of arts and cultural activities. We have conducted a number of studies in each of these subject areas. Many of these studies concerned themselves with the building and maintenance of data sets to record changes over time. Other studies are one-time projects that deal with problem areas involving policy development for the agency as a whole or for the individual programs. Most of what is presented in this chapter comes from our project for the construction of a data series that will provide measures of change in the United States artist population, but some material is also drawn from several ad hoc studies. The Research Division has no disciplinary bias and is not tied to the use of any particular method or data set in its work, but uses all available data and methods to the greatest extent possible, given our limited resources. Nevertheless, the shortcomings of the information available about the American artist are never clearer than when one is working on a

subject like the theme of inflation and the performing artist. An adequate treatment would require data far beyond what is currently available to us. That is why the title of this chapter is "Observations about Inflation and the Performing Artist." We do have some very interesting observations that are relevant but cannot cover the subject completely.

2. The Inflation Factor

The 1977 Census of Service Industries provides the statistic that the payroll in the performing arts for the entire year of 1977 was $762,834,000. The number of paid employees in the week that included March 12 was 75,877. The 1977 census showed an increase in the payroll of 61 percent since 1972 and an increase in number of employees of 30 percent. As can be seen in Table 10.3, during the same five-year period the change in the GNP deflator was 39.8 percent, and the increase in the CPI was 44.9 percent. These are interesting comparisons. They are, however, not very helpful in explaining the condition of the performing artist. The payroll includes many other categories of employees such as administrators and managers, and the base week for the count of the number of employees sets up an interpretative puzzle because of the high degree of seasonality in the performing arts.

Census of Population data let us make several very interesting comparisons between 1970 and 1976 using the 1976 Survey of Income and Earnings for which the Bureau of the Census obtained data from a sample of 150,000 households for the Department of Health, Education, and Welfare. Comparing the data from these two sources, we find that the total number of persons in all artist occupations,

Table 10.3
Summary of Growth of U.S. Performing Arts
Payroll and Employees, 1972 and 1977

	All Performing Arts	Theater	Music
Growth of Total Year Payroll	61%	51.8%	70.4%
Growth of Number of Employees	30%	35.9%	26.0%

National Price Changes, 1972–77:
 GNP Implicit Price Deflator: +39.8%
 Consumer Price Index: +44.9%

SOURCE: U.S. Department of Commerce, Bureau of the Census and Bureau of Economic Analysis.

including those in the performing arts, increased 50 percent, from 600,000 to 900,000 individuals. In this period, however, there was virtually no increase in artists' median earnings, which remained at $7,900 in 1976, the same as in 1970. Female artists' median earnings were at about 36 percent of the median for male artists in 1970 and remained at 36 percent in 1976. The median for black artists' earnings dropped about 10 percent between 1970 and 1976. Considering that the CPI rose 47 percent during this period, artists' median earnings were significantly worse in 1976 when earnings of $7,900 were worth less than $5,400 in 1970 dollars.

The lack of increase in artists' earnings is partially explained by the fact that in 1976 there were about 50 percent more artists than in 1970. The increase in the artist population was largely the result of young persons entering careers in the arts, probably for the first time, and taking jobs at low pay levels. Further, much of the addition to the artist population came from groups traditionally at the low end of the income scale. The number of females in artist

occupations increased by nearly 80 percent, while the males in artist occupations increased at only half that rate. Black artists more than doubled in number during this period.

In 1970 artists' personal earnings accounted for 62 percent of their household earnings, but by 1976 their contributions to their households dropped to 44 percent. Female artists were considerably more dependent on other household members than were male artists and contributed only one-fourth of their total household income in both 1970 and 1976. While artists' personal earnings are relatively low compared with those of all professional workers, artists tend to be members of households with total household earnings that compare closely with total earnings of all professional workers. The latter rose significantly between 1970 and 1976 by about 40 percent, which is nearly as much as the 47 percent increase in the CPI for this period.

The data we are using for 1976 do not provide the opportunity for disaggregation to the same level of detail about individual occupations as was possible for 1970. From the 1970 census we can report that median earnings of actors were $5,936, those of dancers $3,332, and those of musicians/composers $2,958; the median for all of the artists occupations was $7,880. These performing arts occupations had the lowest median earnings of all the artist occupations. For 1976, our dependence on the smaller sample of the Survey of Income and Earnings limits us to differentiating between performing artists and all artists. For performing artists, median earnings were $3,713, and for all artists they were $7,936. These data are presented in detail in Table 10.4, which shows the distribution of earnings in these occupations by earnings groups. You can observe that the performing artists tend to cluster at the low end of the

Table 10.4
Earnings in Artists' Occupations
Compared, 1970 and 1976

Earnings	1970				1976	
	Actors	Dancers	Musicians/Composers	All Artists	Performing Artists	All Artists
Loss	0	0	168	3,035	907	13,431
$0–1,999	3,262	2,373	39,858	110,378	78,998	183,309
$2,000–2,999	1,200	698	8,091	29,840	33,989	72,568
$3,000–3,999	961	700	7,456	31,468	13,765	40,450
$4,000–4,999	666	502	4,905	27,812	17,666	37,415
$5,000–5,999	867	566	5,296	33,768	10,722	30,611
$6,000–6,999	1,173	535	5,111	32,453	16,780	43,411
$7,000–7,999	898	264	4,171	35,151	5,729	32,187
$8,000–8,999	567	166	3,756	37,315	11,721	43,030
$9,000–9,999	367	202	2,231	33,582	2,870	27,874
$10,000–10,999	536	168	3,294	44,196	5,422	34,827
$11,000–11,999	302	167	1,405	25,979	2,748	29,945
$12,000–12,999	569	33	1,536	30,056	6,911	38,792
$13,000–13,999	167	67	730	18,591	3,697	33,168
$14,000–14,999	167	33	732	15,572	4,335	24,045
$15,000–15,999	500	0	1,065	18,033	12,034	38,286
$16,000–16,999	67	0	467	8,873	1,179	24,946
$17,000–24,999	700	133	2,770	38,528	8,358	99,121
$25,000 or more	832	0	2,506	24,764	9,596	55,240
Total	13,801	6,607	95,548	599,394	247,427	902,656
Median Earnings	$5,936	$3,332	$2,958	$7,880	$3,713	$7,936

SOURCE: Tables 23 and 24, NEA Research Division Report No. 12, *Artists Compared by Age, Sex and Earnings in 1970 and 1976.*

Figure 10.1
Earnings of Performing Artists Compared with All Artists, 1976

SOURCE: Table 10.4.

earnings scale and are found in decreasing proportions as you rise on the scale. Yes, there are performing artists that earn more than $25,000 a year, but the number is small. Figure 10.1 presents the data of Table 10.4 for 1976 graphically. Performing artists earned less, both in absolute terms and in relation to the entire artist labor force.

Table 10.5 shows, using 1970 data, that median personal earnings as a proportion of total household income was 27 percent for musicians, 41 percent for dancers, and 47 percent for actors, again at the low end of the scale when compared with all artists.

Table 10.5
Median Artists' Personal Earnings as a
Proportion of Median Artists' Household Earnings, 1970

Musicians	27%
Dancers	41%
Actors	47%
Painters/Sculptors	56%
Authors	65%
Photographers	66%
Designers	75%
Architects	82%

SOURCE: Figure 5, NEA Research Division Report No. 12, *Artists Compared by Age, Sex, and Earnings in 1970 and 1976.*

Our next look at these detailed occupational data will be provided by the 1980 census, and, unfortunately, we are still waiting for these data. The 1980 census will help to explain whether changes in the structure of these occupational labor forces that were observed in the middle of the decade still continue. For example, as Table 10.6 shows, there may be a shift in the proportion of males to females in the performing artists' occupations that runs counter to that for artists as a whole. This change may help to increase the relative median earnings.

So far, this chapter has focused on the employed artist. However, the unemployment situation cannot be ignored. The unemployment rate, as you know, is the ratio of persons seeking work to the total in the occupation labor force. When compared with all artist occupations, the performing arts occupations of actor, dancer, and musician appear to be different in several respects. For example, performing artists typically work for wages, and their periods of employment are usually short. The total labor forces in these occupations are not growing as fast as in many of the other artists occupations; and, in the case of musicians, may be

Inflation and the Arts

Table 10.6
Performing Artists and All Artists
Compared by Sex, 1970 and 1976

	1970	1976
Performing Artists		
Male	94,034 (67%)	175,069 (71%)
Female	45,863 (33%)	72,358 (29%)
Total	139,897	247,427
All Artists		
Male	443,866 (74%)	619,312 (69%)
Female	159,622 (26%)	283,344 (31%)
Total	603,488	902,656

SOURCE: Table 14, NEA Research Division Report No. 12, *Artists Compared by Age, Sex, and Earnings in 1970 and 1976*.

declining. The unemployment rate for musicians seems to be declining as a result of the withdrawal of some persons from the labor force. On the other hand, growth in many of the nonperforming artist occupations is substantial.

Let us consider some graphs that illustrate these tendencies over the decade of the 1970s. Figure 10.2, for actors, shows that a difficult employment situation continued through the entire decade of the 1970s. At the start of the decade nearly half of all actors were out of work. Unemployment dropped to 31 percent by 1976 but rose again by 1979–80 to 35 percent. The total actors' labor force peaked in 1978 at 30,000 persons, but then declined to about 23,000 by 1980.

Figure 10.3 shows the situation for musicians. Here you see that in the early 1970s the employment outlook appeared to be improving, and unemployment was less than 4 percent in 1974, with the number of people employed as musicians on the rise. But then the 1973–75 recession hit,

Figure 10.2
Employment and Unemployment of Actors

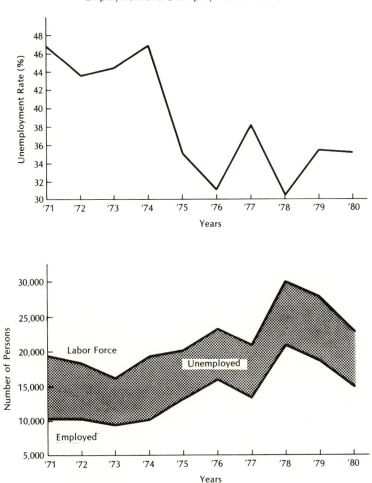

SOURCE: Figure 3, NEA Research Division Report No. 16, *Employment and Unemployment of Artists, 1971–1980.*

Inflation and the Arts

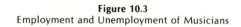

Figure 10.3
Employment and Unemployment of Musicians

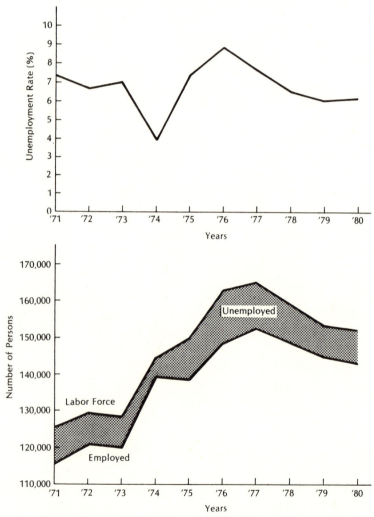

SOURCE: Figure 8, NEA Research Division Report No. 16, *Employment and Unemployment of Artists, 1971–1980.*

and musicians really never recovered. The unemployment rate was over 9 percent in 1976 and was 6.2 percent in 1980. However, the recent reduction in the unemployment rate is misleading because it is ascribable to the decline in the number of people seeking work rather than to an actual increase in the numbers employed. The musician labor force declined by 14,000 between 1977 and 1980, which suggests that many formerly unemployed musicians were no longer pursuing work in their field at the end of the decade. Was inflation a factor? Well, there is no way to be sure from the data we now have to work with. However, this was also a period of double-digit inflation, and the circumstantial evidence suggests that inflation may well have been a contributing factor in the decline of the musicians' labor force in these years. Many musicians may have decided that they had to make a greater contribution to their household earnings than it was possible for them to provide in their artist occupation.

We do not show a similar figure for dancers. The number of dancers in the labor force grew at a relatively slow rate during the 1970s, from about 10,000 in 1971 to about 12,000 in 1980. Unemployment rates, however, are not available because the total number of dancers in the country is relatively small, and too few dancers appear in the survey data for the U.S. unemployment rates to provide reliable estimates.

You may be interested in seeing what one of the more favored occupations looks like in terms of growth of labor force and unemployment. Figure 10.4 shows the designer occupation with its strong growth in number of persons involved throughout the decade, its relatively short-lived increase in unemployment during the 1973–75 recession, and the prompt resumption thereafter of growth and low

Figure 10.4
Employment and Unemployment of Designers

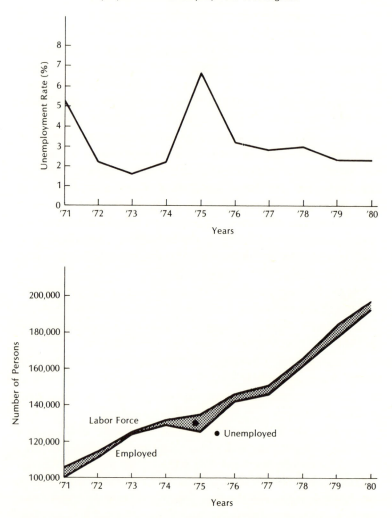

SOURCE: Figure 7, NEA Research Division Report No. 16, *Employment and Unemployment of Artists, 1971–1980.*

unemployment rates. Performing artists may well envy a picture like this.

Part of the difficulty besetting accurate description of the effect of inflation on the performing artists arises from the lack of appropriately detailed information. Our labor force statistics and unemployment rates simply do not tell enough. Even wage bill information about specific arts industries are not sufficient. Careful industry studies within the arts need to be carried out; further, they need to probe into the continuity of individual careers. Such studies have not been conducted in any significant number or detail. There are snapshots here and there, but they do not give us a record of change over time. Let us present two additional observations to illustrate the difficulty. Table 10.7 is about several components of the wage bill for Broadway theater in two time periods, and it shows the results of a calculation comparing the ratio of annual rates of increase of the salaries of performers to other artistic personnel, administrators, and managers. The rates of growth shown in this

Table 10.7
Annual Rates of Increase of Total Salaries in
Broadway Theater, 1965–67 to 1975–77

	Performers' Salaries	Other Artistic Salaries	Administrative Salaries
Production			
Plays	5.6%	11.7%	11.3%
Musicals	2.2%	5.5%	9.0%
Operating			
Plays	5.6%	3.8%	7.4%
Musicals	3.9%	5.1%	16.2%

SOURCE: Tables 9 and 10, NEA Research Division Report No. 11, *Conditions and Needs of the Professional American Theater.*

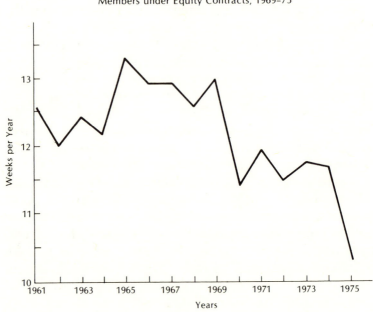

Figure 10.5
Average Work Weeks of Actors' Equity Association
Members under Equity Contracts, 1969–75

SOURCE: Figure 18, NEA Research Division Report No. 11, *Condition and Needs of the Professional American Theatre.*

table portend a smaller proportion of the wage bill for the performing artist.

Figure 10.5 is another snapshot that shows an aspect of the situation for actors working under Actors' Equity contracts. The average work weeks per year under Equity contracts are declining, with the average being below ten and a half weeks in 1975. The reason is important. It is not that there is less work in theater as much as that the growth of Equity membership has been greater than the amount of work available: the average member has less work on his or

her card. Many Equity members also hold cards of other unions and do work under them. It is also no secret that they occasionally work off the card, but it is extremely difficult to get useful information with which to construct a reliable time series of their average wage rate and their total earnings in the acting occupation. We do not have it at the present time.

3. Conclusions

What can be said about inflation and the performing artist from the preceding observations? The typical performing artist appears to be losing ground. However, the typical performing artist is also a member of a household whose total earnings may be staying fairly even with inflation. The performing artist who is the sole household earner may be in a very difficult position. If, as we hypothesized earlier in this chapter, musicians gave up seeking employment in the arts during the latter part of the 1970s, when inflation was very high, to be able to make a greater contribution to their household earnings, then the effect of inflation is very severe.

Despite the fact that earnings of performing artists are lagging far behind the CPI, there seems to be an influx of young people into these professions. These are often females and blacks, whose earnings tend to be in the lower income brackets.

A thorough understanding of the effect of inflation, however, cannot be achieved on the basis of the information that we currently have. Much better data, collected with consistency over time, are needed for a definitive answer.

ADDENDUM

Work on the information obtained from American artists in the 1980 Census of Population is proceeding with full force at the Arts Endowment's Research Division. Release of Bureau of the Census data tapes, called the Public Use Sample Microdata Files, was completed in the summer of 1983 and are being used to produce an extract file containing the census data for artists, as well as members of their households. The new extract file corresponds to the one that was prepared from the 1970 census. The comparative analysis of these data will make possible a major updating of the information in this chapter. Reports on this work should be finished in 1984.

Early examination of the new data shows that the number of American artists increased by 81 percent between 1970 and 1980 and that all fifty states and the District of Columbia participated in this gain. The total labor force of artists in the 1980 Census of Population was 1,085,693 persons compared with 599,066 persons counted in 1970. Expressed as a compounded annual growth, this is a rate of change of 6.13 percent. However, gains by females were far more spectacular than for males. The number of females increased 162 percent from 1970, while males increased 53 percent. In terms of compounded rates, the number of female artists increased 10.09 percent annually during the decade, while males increased at a rate of only 4.32 percent. As a result, females in the artist occupations in 1980 constituted 37.9 percent of the total artist labor force compared with 26.2 percent in 1970. The impact of this in-

crease of females in the artist labor force will probably lower median earnings for all artists in 1980, which would be consistent with the 1970–76 change noted in the body of this chapter. This is one of many topics that are being examined with the new data files.

The Tune and the Piper: Inflation and Financial Support of the Performing Arts

Hugh Southern

WHEN I agreed to participate in a conference on economics and the arts, particularly the subject of inflation and the arts, I suffered as I always do on receiving such an invitation from a strong sense of my lack of credentials for addressing an audience including such eminent figures as my fellow speakers. I did think of reciting to you a couple of qualifications so that I would not be run out of town immediately on the end of a pole.

I am a graduate of King's College, Cambridge, which fortunately has in its history quite a distinguished association with the science or the art of economics. One of the familiar figures on the lawn of King's College when I was there was a life fellow of the college, A. C. Pigou. Life fellows are the only people of King's who are allowed to tread on the 600-year-old lawns, and Pigou took that a step further and brought out a deck chair and occupied his own particular favorite shady spot in the corner of the quad-

rangle, and that reminded Kingsmen passing by of the college's long and honorable ties with the study of economics. Later on in the life of the college, John Maynard Keynes became the treasurer, which was a historically important moment in that at the time Keynes assumed that office King's was one of the poorer colleges, despite having been founded by King Henry VI. But Keynes, in the 1920s, proved to be an extraordinarily shrewd businessman by buying up large chunks of the middle of London at bargain prices, with the result that when the City recovered subsequently, the college moved up on the list of well-endowed institutions in Cambridge from about twenty-fifth to third or fourth. Keynes, therefore, may be said to have had a hand in the success of managing the finances of an institution. I refer to him for another reason, because it leads into what I have to talk about.

Keynes was one of the first advocates in Great Britain of government participation in the arts, and also of a new kind of private patronage for the arts that culminated during the war years with the formation of a group called the Council for the Encouragement of Music and the Arts. CEMA is best remembered in Britain because it sponsored lunchtime concerts in London churches, in factories, in places all over the country where people began at a time of crisis to flock to the arts as a resource for everybody. It was perceived by Keynes and by others in the country at that time that the arts were not any longer the possession of a wealthy elite, that they had something to say to a very much larger public than would have been understood as the potential audience in the past.

One of the sadder things about our current situation is that the governments have not appreciated the lasting or assured importance of the extent to which they have been

able to broaden participation in the arts in this country and in Britain—both directly by individuals and by the attraction of a much wider spectrum of private giving, both from individuals and from corporations. Now, I don't think the government here has been alone in that initiative any more than it has been in Britain, but we are certainly looking at a future where the relative importance of contributors to the arts is going to change, and it is going to change to some extent because of inflation. I have noticed that all the speakers at the conference have had quite a bit of difficulty, as I do, in staying strictly and closely with the topic of inflation and the arts, and that can't be helped. But it is quite certainly true that support of the arts as a government commitment has to be fought for and won all over again. The war that is now taking place is against reductions in government support or the diminution of support by the mere maintenance of support at present levels—what we are witnessing through inflation is a fairly rapid and important erosion of the role of government in the arts. I would not confine those remarks simply to the federal government. I do not believe that arts councils throughout the country that have enjoyed quite substantial increases in funding in the last ten years—very substantial increases in some cases—are going to, during the next five years or maybe longer, enjoy a continuation of that rapid expansion. But if they stand still, their support, through the effects of inflation, will be materially reduced within a very short time. I dare not play with figures in this company, but I believe that inflation, even running at the rate of 7 percent, cuts the value of a dollar in half in less than a decade. This means that if we assume that the level of support from governmental sources remains about where it is now, for, say, the next four or five years, we are going to see a very substantial

reordering of the resources in this country devoted to the arts. And that reordering is a difficult one to predict.

There are some signs nationally that the individual giver is either not increasing giving in step with inflation or is changing some habits of giving as social changes and other demands are made manifest. In 1980 the United Way reported a 7 percent increase in giving, which is substantially less than the rate of inflation in that year. That is a pretty massive reduction in the real resources that United Way provided. Although giving on a national scale from individuals was up in the same year by 10 percent, that didn't meet inflation either. And the direction in which the additional giving took place was not necessarily one that would favor the arts.

We are going to see some changes in legislation; we are going to look at the effects of the provision of a deduction to all taxpayers, not only in addition to those who itemize. It would be very optimistic indeed if people in the arts concluded from the enactment of such additional incentives that there lies ahead some vast increase in support from private individuals. I don't see it. I believe that if there is an increase it will be incremental, and I think it is going to be very difficult for the arts, as it were, to "buy into" the philanthropic structure that provides for many services in this country, because it is extremely difficult for us to argue the case for the arts, given the vast dimensions of social services, health services, education, and so forth. And particularly at a time when resources are short, I think that we are unlikely to succeed.

Consider now the foundations. Foundations are misperceived by most people in the arts; we look on them first of all as if there were something definitive called a foundation, which there is not. There is only a legal form of or-

ganization for the giving or deployment of resources by wealthy individuals or corporations that may or may not take the form of an institution like the Ford Foundation, having a professional staff that considers policy matters in a very serious vein. By far the greater amount of money in foundations in this country is funneled through foundations that are simply vehicles used by an individual to express his or her interest in one or another philanthropic field; giving is at the donor's behest. Such a foundation has no professional staff, and I am quite certain that if you write the great majority of them a letter you will not get a reply because in effect they have no objective existence: they exist only on paper. The board of trustees meets once a year, and its business is done in a couple of hours. The donor's wishes are the determinant of how that foundation will spend its funds.

Foundations such as Ford, Rockefeller, the Carnegie Endowment, and so on—which is what I think most people think of as foundations—are in a very different position. And they are not, for good and honest philosophical reasons, to be relied on as a steady source of support for the arts, precisely because they have adopted the role of pump priming—or starting organizations and then moving on. They generally move on much too quickly—three years for any institution is far too short a time for it to be able to develop alternative resources. But, were foundations to abandon this role, we would be losing a very important source of new initiatives in all the sectors that are not for profit—not only in the arts, but, for example, the current interest that the Ford Foundation has in the problem of employment among women and minorities. Incidentally, this is a real and objective problem within the realm of the arts also. Unless a foundation is willing to take up new

challenges rather than simply providing continuing support of existing organizations, we will be sacrificing the possibility of moving forward in new areas that rightfully should claim our attention.

The other thing about foundations that I think should be said—and this applies even to Ford and to the Carnegie Endowment—is that their own somewhat conservative management of resources is such that their portfolios over time are likely to be, and in recent years have been, immensely eroded by the effects of inflation. There is a tremendous amount of foundation money in this country that is tied up in 2.75 percent bonds, the capital value of which has shrunk drastically. The somewhat conservative boards of trustees of those foundations in these circumstances are going to say, "Well, guys, this is really time to retrench or reconsider." During the last five years almost every major foundation in the United States has spent much of its time reevaluating its programs. I think that the major reason for that reevaluation is the extent to which foundation assets have been affected by changes in interest rates, which are also linked to inflation. They have been drastically affected by the malaise of the investment markets and by the persistent problems of money, interest rates, and inflation.

All this means that foundations, at least from the point of view of the arts, should be regarded as being on hold, and probably remaining on hold for a good long time to come. This does not preclude some individual initiatives. There is always room for some bright manager to give them a good proposal and to have it funded. But I don't think that we can look to any kind of restoration of substantial foundation initiatives in the arts; even if these took place, they would be totally dwarfed by the present financial size and needs of arts organizations throughout the country.

So, having more or less killed off the government and expressed some doubts about the individual donor and the foundations, I find reason for gloom about these three sectors of future support for the arts.

For a number of reasons we should take a look at the roles of business and the corporation. There is a great division in the corporate community (and I think it is worth referring to as an introduction to this topic) as to whether the government should be present in the arts or not. I have been rather startled at a couple of meetings lately to hear some very high-level corporate captains dismiss government participation, and say that in effect they are better qualified than anyone else to look at the future of the arts, to support it, and to shape it. Even those corporate chairmen of the board who *do* believe in government support have also suggested that they are going to take some new initiatives. Corporations may not be willing to give everything that everybody feels they want or need, but there is most certainly going to be a larger role, both in absolute giving and in terms of business participation in the way the arts landscape is shaped in the immediate future.

I was in Dallas in June at a conference of the American Symphony Orchestra League, and I had the pleasure of attending several sessions that discussed the possible future role of corporations in the arts in America. There was one address, which was particularly striking for its honesty, candor, and thoughtfulness, given by Stanley Goodman, chairman of the St. Louis Symphony, and also a former chairman of the board of the Federated Department Stores, and therefore an authenticated blue-blood corporate tycoon. He has given a great deal of his time and his money to the support of an arts institution—indeed, a number of arts institu-

tions—in the past. He prophesied a growth in corporate profits, certainly in excess of inflation rates, which will yield an extraordinary increase in corporate funds that might be available to the arts. He believes that the trends of the last several years encouraged by institutions like the Business Committee for the Arts have also indicated that the corporate role is going to increase. Yet, I do not believe that the corporate role will be simply to step in and assume the role the government has taken so far. It is going to be very distinctly a corporate role. Mr. Goodman went on to say that the best prospect for arts institutions seeking business support was to organize themselves along the lines of the modern corporation. He discussed the model of a symphony orchestra operated with a corporate organization and outlook: a symphony orchestra with management by objectives, a symphony orchestra with network of committees and committee structures that would take it upon themselves to form the policy of that orchestra, including the choice of the music director. He suggested as indices of achievement attendance at concerts and the amount of applause. And this is when I began to get a little nervous; I could see the Nielsen ratings extended. All this, by the way, was said with a great deal of intelligence and friendliness and a willingness to enter into the life of an institution—to mold it and create it and give to it with generosity.

I was even more worried later in the same day when I heard a vice-president of the LTV Corporation say, in another session discussing corporate giving, that his company, although it was beginning to participate more widely in the arts, was not interested in the particular art form. This was further amplified by another corporate contributions officer, this time from Standard Oil of California, who

said that the state of the art was the last thing that his corporation would be interested in. And then a number of alarm bells went off in my head.

As you see, I'm straying once again from the topic of inflation. It seems to me to be important that the consequences of inflationary pressures on the various sources of funds for the arts be weighed by us very carefully, and that we think through as carefully and as intelligently as we can what kind of sacrifices or changes may be made as the corporations wheel their Trojan horses into the performance halls.

I don't think that one can make any kind of case for a malevolent, destructive, or subversive attitude on the part of corporations. I think it is a great mistake to assume that anybody's motives are wrong or impure. But what I did sense in hearing some of these individuals speak, and I certainly have heard this from other sources too, is a lack of understanding of what it is that makes the art forms tick. We heard earlier today a plea from a professional musician for attention on the part of orchestra management to the whole question of the performance of new work, no matter how difficult or improbable, no matter how inadequately rehearsal time could be provided, or indeed how poorly the audience might attend. In the symphony orchestra today (and there are analogies in other art forms), there is a crisis of the soul going on about what the artistic role of an orchestra is going to be in the future. Unless that question is resolved satisfactorily, the symphony orchestra does indeed deliver itself over to the prospect of becoming no more than a museum.

I was interested that Michael Walsh referred to Shaw's ability, which is very rare, to look at an art form in a certain time and know what was going on in it with some degree of

certainty. Right about Wagner, wrong about Brahms. In our day it is even more difficult to do that, first of all, because we have a great diffusion of agreed-upon standards with reference to what an art form should be, and second, because we tend—particularly in this country where we love to quantify everything and measure it—to lose sight of the extraordinary unpredictability of art, the lack of an equation between inputs of money and outputs of artistic excellence. And there is no formula—there can be no formula— and those who try to devise such a formula are probably going to suffer lives of incredible torment and difficulty. What we have to agree to is that some resources be provided, and then hope that the Martha Grahams or the Merce Cunninghams or the Boulezes will emerge from whatever the environment might be. And people working in the arts have a duty, if their consciences are alive at all, to reflect very, very carefully on the way in which they are participating to any degree at all in the regeneration of the art form. It is paradoxical that in this country government has possibly been more effective than any other agency in this particular area. I think that that is a function of the system.

I have a kind word to say for bureaucrats here. What happens when you set up an agency like the National Endowment for the Arts and some money is pried loose from Congress is that you go out and hire a young, intelligent, idealistic, and professionally well equipped staff who immediately develop an attitude toward the art forms over which they have some kind of stewardship. They have an enormous amount of pride in being well informed, and being young they are inclined to be rather adventurous about the art form that they are dealing with. And one of the extraordinary paradoxes of the NEA is that if you look at its programs and allow for a certain amount of political

giving, a certain amount of waste, and a certain number of experiments that do not turn out very well, the NEA by and large has succeeded in supporting in one way or another almost every important artistic initiative in this country in the past fifteen years.

Now, if we are in doubt about what the government role is going to be, and we surely are in doubt, and if we accept that there is going to be some fairly substantial change in the way in which resources are drawn into the not-for-profit arts sector, then this question of who will support the arts is going to have to be dealt with by administrators. Our concerns have to be expressed with an eloquence and certainty and persuasiveness that we really haven't achieved very well. If we just let inflation and the changes that are consequent upon it happen to the arts, we are going to end up ten years from now with a number of art forms that run a very great risk of being reduced in their adventurousness and reduced in their ability to experiment, except on a very small scale.

I do agree with the person earlier who said that money or resources are not necessarily the answer to anything, and that the provision of new technical skills or larger casts or more elaborate settings is not necessarily a clue to the excellence of an art form. I am reminded in this connection of Jean Cocteau's remark when somebody explained to him the miracle of cinemascope, the wide screen, and stereophonic sound, and he said, "Aha, the next time I write a poem, I will use a larger sheet of paper." But, at the same time, one does not want to see artists of necessity reduced to a small canvas or to a poverty of technical resources. Somebody mentioned *Nicholas Nickleby* in New York, and I thought I would pick up on that. It is a very expensive

production, and by the way, it is worth $50 a ticket. It is, however, no accident that work of this extraordinary audacity and cost comes out of a subsidized institution, the Royal Shakepeare Company, because no commercial producer would dare risk those resources on a stage work designed primarily for only the rather well-educated and literate segment of the public.

We must not lose sight of the fact that the chief source of new theater material in this country is now from the not-for-profit sector. The out-of-town tryout has become absurdly expensive. The risk of a full-scale Broadway production is totally disproportionate to any prospect that there is of successfully developing new works straight onto the Broadway stage. So, speaking of the field that I know best, the theater, the partnership—although it may be a tense one at times, between the not-for-profit sector and the Broadway theater, which is another way of saying the mass market—is one where it is greatly in the interest of both sides to preserve the health of the subsidized, not-for-profit groups.

In looking at the effects of inflation on the sources of funding for the arts, we have to make a much better, and better informed, case for the interdependency of the small arts or the minority art or the art less well attended or less recognized, with those arts that later on become part of the mainstream. Even in *Jubilee* (a stage extravaganza produced by Donn Arden at the MGM Grand Hotel, Las Vegas, 1981), which partook of the theatrical vocabulary of some bygone age, there were still very definite signs that those who designed and staged it were au courant with a lot of production ideas and a lot of technical resources that were in fact developed by other people far away and not for large sums of money. The idea that one can simply ignore these kinds

of contributions from the artist who is not yet recognized will defeat all our efforts, no matter how resourceful the director of development, no matter how good the fundraising brochure, and no matter how willing the board of directors is to go out and scratch for more bread.

12

On Inflation and the Arts:
A Summing Up

Hilda Baumol and William J. Baumol

A CONFERENCE such as this is apt to contribute a profusion of ideas, and this one has provided at least its share. An attempt to summarize the rich body of materials that has been offered to us in these two days is, therefore, an act of presumption that is condemned beforehand to omit a variety of significant contributions. Knowing this, we will nevertheless proceed as best we can. But, before turning to the ideas that have been contributed by others, let us offer a bit of factual material that may perhaps help to anchor the discussions of inflation and the performing arts. The data will suggest that in the decade of inflation the arts fared better than might have been feared. But, for a variety of reasons, this conclusion must be considered tentative at best.

1. Imperfections of the Data

We must reemphasize at the outset the paucity of the available data. Statistics on the performing arts are plagued

173

by enormous gaps; by unstandardized reporting; by changes in size and composition of virtually any sample, which undermine calculations of trends; and by ambiguities in definition that impede interpretation. One of the consequences is that it becomes necessary to switch from art form to art form in order to produce the semblance of a coherent story, turning to orchestras and regional theaters for data on costs, to the Broadway theater when we require data on attendance and ticket pricing, and to the regional theaters for data on variations in government support by size of enterprise. It should also be emphasized that many of the figures that we offer were provided to us with cries of caveat emptor by those who compiled them.

Audience Size

One of the influences that seems to have helped to shield the arts from the worst effects of inflation has been a growth in attendance. The advent of the cultural boom has been proclaimed many times, somewhat like the economic forecaster who succeeded in predicting twelve of the last four recessions. In the past, careful analysis of the data indicated that those who announced the boom were excessively sanguine. But more recently indications have emerged that audiences have really begun to grow and to proliferate throughout the country. One hears of an explosion of attendance at dance performances; museum exhibits draw crowds that seem to be unprecedented; and live theater outside New York seems to have recovered from the devastation it underwent in the early 1920s with the advent of the motion pictures. Such data as are available tend to confirm these impressions. Using figures provided by the

American Symphony Orchestra League (ASOL), we find that attendance at a sample of orchestras rose fairly steadily from 18.3 million in 1974 to 22.8 million in 1981. This represents not only an absolute increase in audience size but also an increase relative to population. During the seven years in question, these figures represent a rise 17 percent greater than that of the United States population. Attendance at the Broadway theater has gone up even more spectacularly, from 5.7 million in 1973–74 to 10.1 million in 1981–82. This is a rise 69 percent greater than that in the United States population. Performances of national touring companies of Broadway plays in the largest cities are estimated to have attracted 7.4 million people in 1973–74, and 15 million in 1981–82, a rise 95 percent greater than that in the United States population.[1] In sum, judging by these cases, not only are more people attending live performance, but a substantially greater share of the population is doing so and in a wider geographical area.

Finances of the Arts Expressed in Real Terms

In a number of other countries, financial statistics on the arts are presented with corrections for the effects of inflation. Thus, Canadian, French, and Swedish data are expressed, respectively, in dollars, francs, and kronor of constant purchasing power. In the United States, for some reason, this is rarely done, and consequently it is difficult to evaluate from the report that some state arts council has increased its budget, say, by 11 percent, whether this really represents an increase or a decrease (in the sense that it may not really make up for the ravages of inflation). It may, therefore, be useful to provide some such information for

the United States. We do this by using data on orchestras, because the sample of orchestras is fairly homogeneous from year to year, and because it offers us as comprehensive a body of comparable information as is provided by any artistic activity.[2] Table 12.1 translates into dollars of 1972 purchasing power the available statistics on income, expenditure, performances, and audience size for a sample of orchestras from 1973–74 through 1979–80.

The first thing to be noticed in the table is that virtually every financial figure has risen substantially during the period despite the fact that these figures are reported in dollars of constant purchasing power. Thus, we see that earned income, government grants, private support, and expenditures have all increased far faster than inflation.

The bottom line, the deficit, has also gone up, even in real terms. But the rise was relatively modest, amounting to $400,000 for the entire group of orchestras—an increase of 14 percent over their initial deficit.

The Behavior of Costs

The cost disease, which seems to contribute so heavily to the financial problems of live performance, is perhaps the most widely cited conclusion of the fourteen-year-old Twentieth Century Fund report on the economics of the arts with which both authors of this chapter were concerned.[3] The argument is that live performance is at an inherent disadvantage relative to manufacturing in terms of the scope for productivity-increasing innovations. Since the beginning of the nineteenth century the productivity of labor in manufacturing has probably risen something like 2,000 percent, but the number of person hours directly required to

Table 12.1
Real Income and Expenses of Major, Regional, and Metropolitan U.S. Orchestras, 1973–74 to 1979–80
(using GNP implicit price deflator, 1972 = 100, in millions)

	1973–74	1974–75	1975–76	1976–77	1977–78	1978–79	1979–80	Percent Increase ('73–'74 to '79–'80)
Earned Income								
(Ticket Sales and Fees)	$ 41.6	$ 44.9	$ 48.5	$ 52.4	$ 56.8	$ 62.5	$ 66.7	60.3
Tax-supported Grants	14.0	14.8	15.0	14.7	16.5	19.4	18.8	34.3
Private Sector Support	29.0	27.4	28.9	31.3	33.2	37.6	40.4	39.3
Endowment and Interest	11.3	10.9	10.0	10.4	10.6	11.5	13.0	15.0
Gross Income	$ 96.0	$ 97.9	$102.4	$108.8	$117.0	$131.0	$138.9	44.7
Artistic Personnel Expense	$ 60.2	$ 61.0	$ 63.5	$ 67.8	$ 69.7	$ 73.3	$ 76.6	27.2
Production Expense	25.0	26.5	27.2	29.2	32.8	38.9	45.0	80.0
Administrative Expense	13.6	14.3	15.1	16.6	17.9	21.3	20.6	51.5
Gross Expense	98.8	101.9	105.8	113.6	120.4	133.5	142.2	43.9
(Deficit)	(2.8)	(3.9)	(3.4)	(4.8)	(3.3)	(2.6)	(3.2)	14.3
Total Performances								
(thousands)	13.9	14.2	14.8	17.4	18.0	22.1	22.2	—
Attendance	18.3	18.3	20.1	21.0	21.4	22.4	22.6	—
Average Weekly Salary (Major Orchestras, in dollars)	$259	$245	$245	$255	$257	$259	$244	-5.9

SOURCE: The American Symphony Orchestra League is the source of the nominal figures.

perform a Mozart quintet has not changed. As a result, cost per unit of output in the arts will rise persistently and cumulatively faster than those in the economy as a whole. What has not been widely noted is that our historical data seemed generally to confirm this cost pattern for all states of the economy *with the notable exception of periods of inflation.* For example, financial data for the New York Philharmonic going back to 1842 indicate that costs failed to keep ahead of the general price level only during the inflationary periods associated with the Civil War and World Wars I and II.[4] We conjectured that this lag in outlays during periods of inflation was attributable to erosion of philanthropic support, measured in real terms, and to money illusion that inhibited rises in nominal ticket prices, particularly during a time of national emergency.

Since we are now undergoing the most protracted and substantial inflation in recent American history, it may therefore be interesting to see whether these phenomena are recurring.

Before turning to the statistical evidence, it may be worth discussing the nature of the phenomenon rather briefly. Presumably, in inflationary periods relative costs per unit of "output" in the arts have lagged because economy was forced upon the organizations. Resistance to rising ticket prices, a slowdown in growth of real contributions, and other such pressures probably forced modifications in behavior such as reductions in rehearsal time, simpler sets and costumes, recourse to plays with smaller casts, reduction of touring activity, and the like. In short, the "economies" that the arts were apparently able to achieve in inflationary periods very probably represented substantial changes in the way they carried out their activities, some of which may not be considered altogether desirable.

Let us now look at the recent data. In the case of the orchestras, we find that in 1972 dollars over the six years in question cost per attendee rose by 16.5 percent, from $5.40 to $6.29, or by an average of 2.5 percent per year, whereas cost per performance actually declined by 10 percent, from $7,100 to $6,400, or at an average annual rate of 1.6 percent. These results are, clearly, mixed. While cost per member of the audience did rise, cost per performance actually declined significantly. The immediate explanation is that the number of performances rose more than twice as rapidly as audience size. But this does not mean that there was increasingly poor attendance; there is more to the story. One of the ways in which the orchestras have adapted themselves to inflation is by presenting, with growing frequency, chamber music performances using only a small portion of the orchestra's musicians. Such chamber performances are, of course, intended for smaller audiences, and this may well explain much of what underlies the behavior of the unit cost figures.

The data on orchestras tell us a bit more than this. We see from Table 12.1 that, while overall orchestral costs during the six-year period rose about 44 percent, production costs rose 80 percent and administrative costs went up about 52 percent—that is, costs in both of these categories went up far faster than the average. The only type of expenditure that underwent an increase that was below the average—it went up only 27 percent—was the outlay on artistic personnel. The same phenomenon occurred in the nonprofit theaters. According to the 1981 statistical report of the Theatre Communications Group, while administrative expenses rose sharply, "as a percent of total expenses, artistic salaries have steadily declined from 29 percent in 1977 to 24 percent in 1981."[5] This may, perhaps, suggest one significant

way in which costs are most easily kept from rising too quickly in inflationary periods.

This is confirmed by the figures on average salary per week of players in the major orchestras. In constant 1972 dollars these declined from $259 per week in 1973–74 to $244 in 1979–80. This represents a relatively modest fall of roughly 1 percent per year. Moreover, even that observation is somewhat misleading and really may represent no more than a fortuitous fluctuation in a single year. If we drop the last year in our data, we find that during the previous five years musicians' salaries, measured in constant dollars, managed to hold their own.

Moreover, it must not be concluded from these figures that during this period musicians' real incomes were shrinking. Between 1973–74 and 1978–79 (the last year for which we have data on the number of musicians employed by the orchestras) artistic personnel expenditures per musician rose from $7,200 to $11,336; or, in dollars of constant 1972 purchasing power, they went up from $6,200 to $6,850, an increase of 10.5 percent. We have no way of telling how much of this represents a rise in compensation of conductors (who are included in the figures) and how much simply reflects an increase in the amount of time devoted to orchestral work by the typical musician.

Ticket Prices

The most consistent source of information on ticket prices is the Broadway theater, for which we have data going back to the 1920s. Using figures on top ticket prices as a rough indicator of the facts, we find that in the half century between 1929 to 1979 these actually declined substantially in

terms of dollars of constant purchasing power. For straight plays this figure decreased by 9 percent, while for musical comedies it actually went down by nearly 30 percent. This means that, over the years, Broadway ticket prices have not even kept up with inflation. Thus, today's ticket prices may not really be quite as high as they seem.

Yet, in the recent six-year period with which we have been dealing, the picture is more mixed. During that period the real price of musicals fell by 9 percent, but that of straight plays went up sharply, rising 25 percent.[6]

We may make a rough comparison with the orchestras, taking as a very approximative average ticket price the total earned income and fees divided by audience size. We find that the figure went from $2.27 in 1973–74 to $2.95 in 1979–80, a rise of 30 percent in constant dollars.

With audiences growing and real ticket prices, by and large, rising, the real rise in earned income is an arithmetical consequence. Indeed, in the data on orchestras, this was by far the largest single source of increase in income. During this six-year period, while overall income rose by some 45 percent, earned income rose more than 60 percent, with no other income source coming close to this figure.

Private Contributions

What about private and public philanthropy? Data on private support are particularly difficult to acquire. Statistics on foundation grants are aggregated into a broad category, "humanities," while Internal Revenue Service figures on contributions by individuals are far less disaggregated than this and are, consequently, unusable for our purposes.

We have statistics on real grants by private foundations. In dollars of 1972 purchasing power, foundation grants to the humanities rose from $54 million in 1973 to $84 million in 1980, a rise of 56 percent.[7]

This figure is somewhat higher than that indicated by the data on orchestras for private support from individuals, foundations, and business firms together. In real terms, these rose by a bit more than 39 percent over the same period. One may guess from these data that individual and corporate contributions fell slightly behind those of the private foundations. Yet, perhaps what is most noteworthy is the fact that private contributions stayed well ahead of the inflation rate. In a decade plagued by recession, an uninspiring stock market performance (to say the least), and some years of declining real wages, a 40 percent rise in real contributions in a six-year period is no mean accomplishment. Yet such contributions failed to keep abreast of the 45 percent overall rise in real orchestral income, let alone the 60 percent rise in real earned income.

Support by State and Federal Governments

The figures for the orchestras also tell us about the combined contributions of the public sector, which rose, in constant dollars, by 34 percent during the six-year period. This rise was also very substantial, but it does trail by about 5 percentage points behind the contributions of the private sector.

In light of the extraordinary performance of state and federal support, to which we will turn next, the fact that government was the slowest-growing source of aid to the orchestras is perhaps somewhat surprising. Table 12.2 re-

Table 12.2
State Arts Councils Appropriations—Total—All States
(1966–80)

Year (fiscal)	Amount (millions)	In Constant Dollars (millions of 1972 dollars)
1966	$ 2.7	$ 3.5
1967	4.9	6.1
1968	6.7	8.2
1969	6.8	7.9
1970	7.7	8.4
1971	26.9	28.0
1972	22.2	22.2
1973*	20.6	19.5
1974	30.3	26.4
1975	58.1	46.3
1976	57.7	43.7
1977	50.4	36.0
1978	62.1	41.4
1979	79.3	48.7
1980	99.1	55.9

SOURCE: Associated Councils of the Arts.
* *Estimated.*

ports the total appropriations of the state arts councils from 1966 through 1980, both in current dollars and in dollars of constant (1972) purchasing power. The table shows that in real terms this amount increased more than fifteenfold in the fourteen-year-period—a truly astonishing record. Over the six-year period we have been discussing it more than doubled.[8] Though there were brief intervals of retrenchment, the upward march in the arts council budgets continued and has gone up 35 percent in real terms in the two-year period—1979 and 1980.

The growth in support by the federal government has been equally remarkable. Between 1969 and 1980 real support from the National Endowment for the Arts went up just about ninefold, from just under $9 million 1972 dollars to a

Table 12.3
National Endowment for the Arts
Total Program Funds, Current and Constant Dollars, 1969–1980

	Funds (millions of current dollars)	Real Funds (adjusted by GNP implicit price deflator, 1972 = 100)
1969	$ 7.8	$ 8.99
1970	8.3	9.08
1971	15.1	15.73
1972	29.8	29.8
1973	38.2	36.1
1974	50.8	44.2
1975	74.8	59.6
1976	82.0	62.1
Trans. Qtr.	33.9	
1977	94.0	67.2
1978	114.6	76.4
1979	139.7	85.8
1980	142.4	80.3

SOURCE: National Endowment for the Arts.

little more than $80 million 1972 dollars in 1980. In the six-year period we have been discussing, the figure grew about 80 percent.[9] (See Table 12.3.)

Table 12.4 throws more light upon this incredible record. It compares real support by the federal government in the United States with the corresponding data for three other countries for which the information happened to be available to us. For comparability, the table tells us for each year how much the real contributions of the four countries had risen in any particular year in comparison with their 1970 levels. Thus, we see from the 122 figure for Canada in 1971 that real contributions there had gone up 22 percent; in Sweden by that date they had risen 15 percent; while in the United States they had gone up 73 percent.

Table 12.4
Indices of Real Support of the Arts
By National Governments
Canada, France, Sweden, and U.S., 1970–80

Year	Canada	France	Sweden	U.S.
1970	100	100	100	100
1971	122	NA	115	173
1972	123	NA	127	328
1973	149	NA	135	398
1974	147	NA	148	487
1975	147	150	158	656
1976	161	161	181	684
1977	166	200	200	740
1978	169	200	—	841
1979	194	—	—	945
1980	—	—	—	884

SOURCE: Arts agencies for the respective governments.
NOTE: We must thank Harold Horowitz of the NEA for assembling these figures for us.

We observe, first, that in each of the four countries the index went up quite steadily throughout the decade. This means that everywhere government support stayed well ahead of inflation, and in fact just about doubled in purchasing power in Canada, France, and Sweden over the years for which we happen to have data.

However, we see that, taken just in terms of growth, the United States record puts the others in the shade. Consider 1977, the last year for which we have data for all four countries. By then, real support in Canada had gone up 66 percent; in both France and Sweden it had risen 100 percent; and in the United States it had gone up 640 percent from 1970.

Lest we leap to the conclusion that the United States has been far more generous to the arts than other countries, it is important to remember that one who starts from far behind

may not catch up even by running very quickly for a while. A rough calculation indicates that in 1978 government support per capita in France was more than twice as high as that in the United States; in Finland it was about three times as high as ours; and in Sweden, with its tiny population, it was about eighty times the American figure!

The Proposed Cuts in Federal Support

We turn, finally, to the question of the hour—the cuts in funding for the arts proposed by the Reagan administration. As we all know, it was initially proposed that the 1981 and 1982 budgets of the NEA be reduced by more than 50 percent from the figures proposed by the Carter administration, though, in fact, the first actual cut occurred in the 1982 budget. The relevant question is: How devastating an effect are such cuts likely to have upon the arts? The question is not easy to answer, and we can only offer some partial and imperfect information on the subject. We shall see that, although some of this information is disquieting, some of it is reassuring to a limited degree.

First, we may inquire about the magnitude of the likely effect relative to the overall finances of the groups that will bear its burden. Once again, we turn first to figures on orchestras for guidance. There we find that in 1979–80 public support amounted to less than 14 percent of the total expenditures of the orchestras. Assuming that half of this figure comes from state and local sources, this reduces the federal contribution to less than 7 percent, and a 50 percent cut in this amount yields a net loss of support equal to some 3.5 percent of the budgets of these orchestras. Such a cut will, of course, be very painful, but it need hardly be fatal.

Data for the nonprofit theaters appear to strengthen this conclusion. A sample of 60 theaters compiled by the Theatre Communications Group indicates that almost exactly 5 percent of the group's budget was derived from the NEA in 1980, while for a sample of 147 theaters the figure was 4.3 percent. Thus, for them a proportionate cut in NEA funding would decrease the group's total income by no more than 2.5 percent.

A sophisticated econometric analysis of the subject has been carried out by Professors Burkhauser and Getz of Vanderbilt University.[10] Taking account of the effects of matching provisions that have accompanied NEA grants as well as the evidence on price reactions of audiences and budget responses of performing organizations, the authors conclude:

> The proposed reduction in federal subsidies will certainly have an effect on orchestras. Unless additional private subsidies are found, ticket price will go up, fewer performances will be given and fewer musicians will be hired. We estimate, however, that despite the large percentage cut in federal subsidies, the actual number of performance weeks cut is not great. Under the Carter budget, subsidies would have produced 193 additional weeks of symphony performances in 1982. Under the Reagan budget, this falls to 96. This amounts to a fall in performances and musician hires of 5.6 percent.[11]

Thus, these results would appear to confirm that the effects of the NEA budget cuts are likely to be painful but hardly devastating.

These are, however, average figures. Some groups and some individuals will certainly be hurt more than others. To some extent, this distribution will be fortuitous if not

random, but the conventional wisdom suggests that there are likely to be consequences that follow a more systematic pattern. In particular, it has been suggested that older, more established organizations offering performances that are "safer" and more conventional will suffer least because it is the smaller organizations that offer less conventional works that are the more dependent on government support. The facts seem to support this hypothesis only partly. Pertinent but highly aggregative figures are provided by the Theatre Communications Group,[12] which constructed two samples: a group of 30 theaters with large budgets (over $500,000 per annum) whose average income in 1980 was $1.8 million, and another, also of 30 (smaller-budget) theaters with an average 1980 income of $280,000. (Both samples are composed of theaters that have provided data to TCG for each of the five years since 1976.) It turns out that for the two groups the share of the NEA grants in the total budget was nearly identical—5.1 percent for the larger theaters and 5 percent for the smaller.

More detailed information was gathered by a Princeton student under the supervision of one of the authors of this chapter.[13] A telephone survey of 31 New York theatrical organizations was carried out that included organizations as established as the New York Shakespeare Festival and the American Place Theatre and as experimental as Mabou Mines and the Wooster Group. A half-dozen black and Hispanic theaters were also included. For each theater the NEA grant was measured as a percentage of total budget; that is, for each theater the percent of its financing derived from NEA was calculated. This figure was then related to the total budget of the theater. Figure 12.1 shows the results. In this figure each dot represents a different theater. For example, the circled dot is a theater whose annual

Figure 12.1
Share of NEA Funds in Theater Budgets by Size of Budget

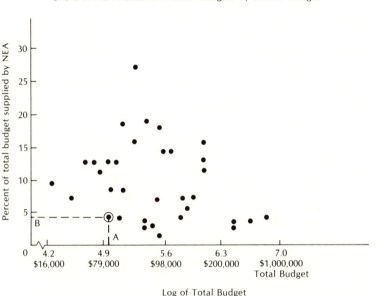

Log of Total Budget

SOURCE: Survey by William B. Conley (see note 13).

expenditures are about $80,000 (point A) and it receives
about 4 percent of its budget from the NEA (point B). Note
that the dots are scattered almost randomly through the
diagram, meaning that there was no systematic relationship
between the size of a group's annual budget and the share
of its outlays provided by the NEA. From this sample, then,
one cannot conclude that smaller theaters are more depen-
dent on federal support than larger theaters.

The same data do, however, offer some little support to
another portion of the hypothesis—that relating to the ex-
perimental character of the offerings. Some of the theaters

in the sample were divided impressionistically into three groups: those that provide performance of more or less conventional type (though many of these devote themselves largely or exclusively to newly written plays); black and Hispanic theaters; and an experimental group comprising theaters that more conservative audiences would consider to offer either plays or productions that are rather outré. While the figures exhibited a substantial range of variation for each group, the following was the average (arithmetic mean) share of total budget contributed by the NEA:

Conventional Theaters	6.2
Black and Hispanic	8.8
Experimental	18.6

Now, these figures should be treated with extreme caution. They apply only to theaters located in New York City. The sample cannot pretend to be "scientific," and the classification of theaters into the three categories is entirely impressionistic. Yet the results are quite suggestive. First, they indicate that whereas black and Hispanic theaters are supported somewhat more generously than the "conventional" groups, the difference may perhaps be considered modest. On the other hand, the "experimental" theaters get just about three times as large a share of their budget from the NEA as the "conventional" group obtains.

All this suggests that a uniform percentage cutback in NEA funding of all theaters will, on the average, hurt small and large theaters just about equally. But it will be far more painful to more unconventional groups than to others.

This does not dispose altogether of the hypothesis that the smaller organizations will suffer more from the NEA budget cuts. For example, recent developments suggest that

larger, more established organizations stand to gain considerably from the imminent growth of cable television to a degree that will compensate to a substantial extent for the loss in federal funds. Smaller groups will largely find this and many other such sources of additional revenue beyond their reach. But much of this is speculation.

One final comment must be offered in this general area. Those who have advocated the proposed cuts in federal funding have suggested that private support may be able to enter the breach. That is, it has been suggested that the arts may be able to offset cuts in federal funding by turning to business and individuals for funds.

But there seems to be little evidence to support this hope. A relevant point is brought up in a recent study by the Urban Institute,[14] which estimated that, "although private giving to nonprofit organizations increased by 38 percent between 1975 and 1979, a further increase of 144 percent would be necessary to offset the Administration's proposed budget cuts and keep pace with inflation through 1984."

This, then, is as far as we have been able to go on the basis of the available data.

2. Overview: Conclusions of the Conference on the Effects of Inflation

We would like to turn now to the second part of our discussion, and try to pull together the major conclusions that can be made from the writings that have been presented in this volume. We will deal primarily with the one subject that was presumably the focus of this conference, that is, the role of inflation, to which all the authors have alluded, though they have obviously ranged far more broadly than that.

If one examines quickly what has been said, it may be tempting to jump to the conclusion that inflation is not among the primary problems facing the arts. The arts are plagued by serious economic problems, of course. But these are perhaps the usual ones that beset them when prices are not rising rapidly. Joe Delaney told us how cost problems arise for the arts out of the competition of hotels and the growing demand for the services of performers. But these would have occurred even if the general price level of the economy had been more or less constant. The mere growth in people's demand for what goes on at Las Vegas and the opening of new enterprises would have had precisely the same real effect. Harold Horowitz and Thomas Bradshaw have told us that some artists' real wages have been falling, but these too may well be attributable to other causes, possibly to the remarkable increase in the supply of performers to which they drew our attention. Herbert Weissenstein implied that the demand for tickets is almost totally price inelastic—he kept reminding us that it is the expensive tickets that sell out first. This again suggests that inflation should be no problem—anytime costs go up in response to rising input prices, one need merely raise ticket prices sufficiently to cover those costs. Irving Cheskin showed us how the self-supporting theater was able not only to recoup its costs but to prosper magnificently throughout the inflationary period—to rise to a degree of affluence that it had not known for some time before. Thus, all these things would seem to suggest that inflation is perhaps just a side issue, a minor tribulation. But this is only what we may be led to conclude from a first glance at what has been said here.

Yet, some disturbing signs, also, were called to our attention. Hugh Southern reminded us of the financial prob-

lems faced by the foundations and the state arts councils. Though, as we have shown, they have kept well ahead of inflation in the amount they were able to provide for the arts, they have nevertheless apparently not been able to keep up with the rise in costs that the arts have been experiencing. Russell Sheldon showed how private philanthropy generally *has* fallen relative to GNP, probably in response to inflation and other economic developments. While attendance has increased dramatically and has played an important role in maintaining performing groups during the inflationary period, Michael Walsh called attention to the insidious threat to standards in programming and performance of musical programs entailed in luring large numbers of neophyte patrons to the concert hall.

Alan Peacock told us that in the United Kingdom, as in the United States, orchestras have managed to keep real costs down, but they presumably achieved these economies only through some painful readjustments. This was confirmed graphically by Richard Reineccius, who reported the case of one organization that, over a ten-year period, had cut in half the average size of casts. I may note here that during the conference Professor White very kindly provided us with a cartoon that shows a stage on which a one-man band is playing or is about to perform, and the announcer says, "due to recent federal cutbacks in aid to the performing arts . . . there will be some changes in this year's production of Beethoven's ninth symphony." The real lesson of this cartoon is that there are limits to cost reduction from this source, that the one-man show has nowhere else to go in that direction. Here we are reminded that when Baumol and Bowen's book on the economics of the arts was first published, we received a letter from a Scotsman who had been a conductor on New York City subways

before World War I. At that time, there were six conductors on each train, and they would get something like two trains through Grand Central Station every minute at rush hours. He gave us the date at which the six was cut to five, then the five was cut to four—until they had finally gotten down to one conductor—with consequences any rider of the New York subways can describe. All in all, we must conclude that although inflation may not be the prime villain of the piece, it certainly cannot be declared innocent beyond all reasonable doubt.

Herbert Weissenstein sums up what may be the consensus of the conference: "The audience is not being led forward. Though current and past standards are maintained, concern for the future and the necessary role of leadership are endangered by protracted inflation. . . . the danger is that when the arts simply maintain themselves they are not leading and, therefore, are not representing excellence."

Thus, we have seen that both the qualified observers who have spoken to us and the data themselves leave us with a very mixed picture. The evidence seems to indicate that inflation is not likely to be fatal to the arts. Sources of support have miraculously managed to keep up with inflation. A rapidly growing audience has also made its contribution, particularly in the self-supporting sector. But there are dangers for which we must keep watch. Inflation has led to changes in mode of operation, to reduced cast size, to more spartan sets, and perhaps to less frequent rehearsal, not all of which can be accepted with equanimity. All costs have not risen explosively, but this has probably been achieved by increasing restrictions upon operations. Sources of support have performed notably and astonishingly, but we cannot assume that this will continue automatically. In short, inflation is a threat and, to some

extent, a damaging influence. There is clearly need for vigilance, though there is no ground for panic. We are confident that the arts will not only survive but will flourish. As always, however, even if doing so exacts no blood and tears, it will certainly require an enormous amount of sweat.

Appendix

The Idea of a Center for the Study of the Performing Arts

William T. White

The Speech Opening the Conference on Inflation and the Performing Arts

Inflation is the theme of this conference. Probably it is the most immediate problem plaguing the arts administrator, and I believe there is little I can now say about the subject that will not be dealt with by our illustrious group of participants who will decide whether inflation is or is not *the* most important economic problem for the performing arts. Certainly the performing arts suffer from other economic problems that deserve and will receive attention. My point here, however, is rather that there are many university disciplines, including economics, that can be applied usefully to the performing arts, and I would like to suggest some of the applications that might be considered. Certainly business studies have much to offer, as do the other social sciences, and although a good deal of academic work has been done on the performing arts from the perspectives of many disciplines, much remains to be done. I will suggest that a center for the academic study of the performing arts can make an effective contribution in continuing and inte-

grating the progress made, and that the interdisciplinary study of this vital cultural area would in turn contribute much to the educational process that is basically the business of the university.

1. Economics of the Performing Arts

In my own field of economics much of our attention is devoted to modern societies which are concerned with economic growth at some reasonable but not destructive rate, full employment, and the maintenance of a reasonbly stable currency. Each of these and its relationship to the performing arts is worth a brief comment.

Certainly, economics can make a contribution to our understanding of economic growth as it relates to the performing arts. We know, for example, that the last few centuries witnessed startling population and world economic growth. Has this great growth enhanced or detracted from the function, the finance, the nature, and the dissemination of the arts in general and the performing arts in particular? Can the performing arts be expected to be affected in the future one way or another by growth of such a nature? Some people like to believe that an earlier, more leisurely world placed the arts in higher esteem than does the hustling world of modern business. But is this thesis really acceptable? This is the sort of question to be pursued by those who find that they share interests in the economics of growth and in the performing arts.

The problem of unemployment in the performing arts cries for attention. In the first place, unemployment rates among performing artists are and always have been extremely high. They are also problematical.[1] How should

the many trumpeters who belong to the Musicians' Union and drive cabs be counted? Are they unemployed or under-employed? Or should they no longer be counted as musicians but only as cab drivers who enjoy music as a hobby? There are interesting attributes of unemployment in the performing arts during business cycles. One can remember that during the Great Depression production workers envied those who played in symphonies and dance orchestras and did relatively better than the average person. These and other matters await the attention of the economist.

Finally, the effect of international monetary fluctuations also offers interesting subjects for the application of an economist's tools. How do the complexities of international exchange affect earnings by travelling artists; the sale of American recordings abroad; tourism attracted by the arts from abroad; and, on the other side, the expenditures made for these? In a deeper sense, how does one estimate the value of cultural exchange in the performing arts? For example, a visit from the Kirov ballet to this country and a return engagement by the New York City Ballet serve to maintain a continuity of mutually desirable relationships between the two peoples even when politically and economically there is almost no other basis for such relationships.

2. Academic Studies and the Performing Arts

Little imagination is required to suggest areas of interest for the business schools in management, marketing, finance, and perhaps even accounting for the performing arts, both on the behavioral and quantitative sides of management study. A particularly fruitful area of investigation may be motivational research, with particular attention to

the organizational relationships that exist in orchestras, ballet companies, and other performing arts groups. Did Toscanini achieve excellence by being a dictator in the organizational sense of the word, or was he supremely gifted in using the language through which leadership on a high level is made possible?

Network analyses such as PERT (Program Evaluation and Review Techniques) and CPM (Critical Path Method) may be adaptable to serve the performing arts, putting at their service these clever techniques for transferring funds, time, and artistic processes to achieve an end result such as theatrical production. The research that has been done on planning, organization, and exchange as they relate to managed social groups should be important in the study of the performing arts as well. Management is a discipline well worth applying to the performing arts.

The academic study of the performing arts can readily expand from business to the social sciences. Some features of the performing arts of interest to political scientists already have been mentioned in connection with international relationships.

There is a unique role for the performing arts as a reminder to all the peoples of the world that they ultimately share some form of common culture. Dance—Oriental, Western, and aboriginal—obviously pursues similar goals in different but mutually comprehensible ways. Subjects of interest to political scientists and historians alike might include the spread and effects of cultural influences, the consequences of certain types of music for political stability (e.g., in the rock music era in the United States), and so forth. These matters, of course, are also of great interest to sociologists and other behavioral scientists.

Behavioral scientists will perhaps find the world of the performing artist of as much interest to them as do the

economists. One day the special position of the dance and songs as carriers of the Navaho culture could perhaps be explained within a model of performing arts and cultural transmission constructed by a good anthropologist,[2] who might also collaborate with an economist in a comparison of the rewards given to the Navaho performers with those given in modern Western society.

It is perhaps not unfair to say to our sociologist and psychologist friends that an investigation of the relation, if any, between modern popular musicians, drug usage, and sex attitudes is overdue.[3] The psychologists among us must also surely be interested in the motivations of musicians that keep them in a profession with incredible rates of unemployment. One day, too, we will probably see a joint study by an economist and a psychologist, and perhaps with a sociologist as well, explaining why wages of performing artists do not respond to differences in supply and demand as they do in so many other markets.

The study of language also must be heavily concerned with the performing arts. There is room in the study of the performing arts for the semanticists and the linguistics scholars. There is room for a comparative study of music and language as methods of communication. Important differences between music and spoken lanaguage also cry for more of the attention of language scholars.[4]

Painting, drawing, and sculpture have long been in partnership with the performing arts, sharing in the creative process and drawing inspiration from it.

3. An Interdisciplinary Center for the Performing Arts

Several of these disciplines have already been effectively used to analyze the performing arts, as the 1966 Baumol

and Bowen book illustrates for economics.[5] There remains endless work to be done, however, in all the disciplines. Given the nature of the Las Vegas economy and its community, a "Center for the Interdisciplinary Study of the Performing Arts" in Las Vegas suggests itself. Such an interdisciplinary center would be a unique contribution to this university to the world of scholarship. It would be valuable in showing the broad community in Las Vegas that one of the university's central concerns is indeed relevant to a major source of the community's interests and livelihood. It would be a convincing demonstration of the unique position of Las Vegas as a major consumer of the performing arts, to be ranked with New York, California, and Chicago.

The center is just an idea at this point, but it is an exciting one. One could visualize annual meetings at which a new discipline is added each year or two, until finally the center fully spanned the many relevant fields.

What is it that the study of the performing arts is to do for the disciplines and the university itself? And how can a center be helpful in the process? These questions are, of course, just elements of a larger one: what it is that universities do for their communities and their students. Today, progress in the arts and sciences is swifter than it ever has been, and we know that subject matter and training that are up to date and practical now will not be practical in a decade or so. Yet the university owes its students something that will be useful to them for the remainder of their lives.

Of all God's creatures, only mankind was given the gift of speech and the written word. Perhaps the most important thing that a university can do is to develop this gift to its highest powers. When the student learns to formulate and communicate abstractions through the rigorous use of language, he or she becomes capable both of initiating and

understanding change and of communicating with others in their disciplines.

The many problems of the performing arts that are of interest to scholars are more or less amenable to interdisciplinary solution only if the disciplines share a rigorous language. In a sense, there is nothing of more practical value in the real social world than good theory that rests to a considerable degree on language.

A performing arts example may be useful. Economics rigorously distinguishes between the short run and the long run, with the long run being defined as a period sufficient to permit some change in the fixed production facilities. An arts administrator must make clear to those being asked to bail out a financially sick symphony whether the problem is replacement of the performance hall, a long-run problem, or a current operating deficit. Surely more than one prospective donor has been lost because those seeking his support allowed long-run problems to creep into their "tale of woe," giving him the impression that he would be pouring money into a bottomless pit. A careful differentiation of capital problems from operating problems using the language of economics affords a common understanding between the orchestra manager and the potential donor.

The distinction in sociology between organized groups and unorganized but commonly positioned groups will be highly useful in sorting out the roles of those affected by the addition or the removal of a performing arts facility. To talk to the members of the middle class or the aged about supporting the performing arts is one thing. To turn to the business service clubs and associations of retired persons for such support is quite a different matter. Yet both types of groupings must be understood and, above all, must not be approached in the same way.

In a way, the performing arts constitute a unique microcosm of our society. This has been touched on earlier in discussing management and the arts. The arts possess two seemingly opposite characteristics, and these seem to be found in about similar proportions regardless of the particular art form that is examined. On the one hand, they require and develop almost the quintessence of organizational discipline. A pas de deux is a pas de deux, and it must be done just so. An orchestra requires total compliance of the members with the director's leadership. Drama provides no exception, and the director can be expected to step on any ad-lib. On the other hand, the performing arts require and stimulate intensive competition. There is nothing more competitive than the quest for stardom—for having what is acknowledged to be the best orchestra or ballet company, or to be recognized as a superstar. The rewards for the top one half of 1 percent in ability in any of the performing arts are sizable, to say the least, while the rewards for those who are only slightly less talented and accomplished often are dramatically lower. Thus, the performing arts incorporate the quintessence of both formal organization and competition, and they combine these seeming opposites in a manner that does not diminish either but, rather, maximizes each of them. Is it reasonable to suppose that in so doing the performing arts can show the way—perhaps they have always shown the way—in which society as a whole ultimately must combine organization and competition? If so, an academic understanding of the performing arts surely must be a necessary part of scholarship in any one of the disciplines devoted to humankind and to society.

Notes

CHAPTER 1

1. There are, however, unfortunate signs suggesting that the problem has just begun to grow more difficult. For example, the Theatre Communications Group, in its most recent annual report (*Theatre Facts 81*), concluded that "1980 was a year of devastation for [the nonprofit] theaters. The lack of financial growth, coupled with enormous inflation, caused the true income of these theaters to shrink. The tremendous 22 percent income gain of current dollars in 1981 was not even sufficient to return the constant dollar position to the 1979 level."

The 22 percent income gain was achieved mainly by increased ticket prices and from secondary activities, such as concessions, program advertising, and rental of the theater to booked-in events. The perception among the smaller theaters is that they are surviving financially but that the cost is the increasing "institutionalization" of the nonprofit professional theater.

2. Jack Poggi, *Theatre in America,* (Ithaca, N.Y.: Cornell University Press, 1968).

CHAPTER 3

1. The Times Square Theater Center is operated by the Theatre Development Fund to offer half-price discounts on unsold day-of-performance tickets. Similar facilities have now been established in other cities.

CHAPTER 4

1. *Conditions and Needs of the Professional American Theatre,* National Endowment for the Arts, Washington, D.C. Report no. 11, 1981.

Chapter 5

1. The Julian Theatre is in a community center atop Potrero Hill in San Francisco, a landmark building designed by Julia Morgan, who also did a slightly more elaborate structure for Mr. Hearst somewhat farther south at San Simeon.

Chapter 6

1. William J. Baumol and William G. Bowen, *Performing Arts—The Economic Dilemma* (New York: The Twentieth Century Fund, 1966).
2. Philip Hart, *Orpheus in the New World: The Symphony Orchestra as an American Cultural Institution* (New York: W. W. Norton, 1973), pp. 299–300.

Chapter 8

1. See A. Clutton Brock, *Socialism and the Arts of Use*, Fabian Tract No. 177 (London, 1915). The Shaw quotation is from Eric Bentley, *Shaw on Music* (New York: Doubleday, 1955), p. 307, and relates to the year 1889.
2. For an examination of the evidence see in particular C. O. Throsby and G. A. Withers, *The Economics of the Performing Arts* (London: Edward Arnold, 1979), chaps. 3 and 7. For the evidence for the United States in particular see G. A. Withers, "Unbalanced Growth and the Demand for the Performing Arts: An Econometric Analysis," in *Southern Economic Journal* (January 1980), pp. 735–42, in which the author concludes that changes in levels of income and changes in the price of substitutes for the performing arts explain most of the changes through time in attendance rates in the United States during the periods 1929–48 and 1949–73.
3. For excellent presentation and analysis of data see Throsby and Withers, *The Economics*, chaps. 5 and 9. For an earlier analysis of the problems of analyzing data on public assistance to the arts in general see A. T. Peacock and Christine Godfrey, "Cultural Accounting," *Social Trends* (U.K. Central Statistical Office, 1973).
4. See Resolution 624 of the Parliamentary Assembly of the Council of Europe on the Democratic Renewal of the Performing Arts, and con-

tained in *Report of the Committee on Culture and Education* (Strasbourg, 1976).

5. Cf., for example, the plea for subsidy to Covent Garden made by its influential chairman, Sir Claus Moser: "the concern of all of us at Covent Garden is for the damage that will be done to us if our grant does not rise *at least* in line with the general rate of inflation. The rate of inflation in the arts tends to outrun the general rate of inflation and this would already mean a reduced grant and lead to crippling damage to what we are trying to do." Royal Opera House, *Annual Report,* 1978–79, p. 6.

6. William J. Baumol and William G. Bowen, *Performing Arts—The Economic Dilemma* (New York: The Twentieth Century Fund, 1966), and Hilda Baumol and William J. Baumol, "On the Finances of the Performing Arts during Stagflation: Some Recent Data," *Journal of Cultural Economics*, 4 no. 2 (December 1980).

7. For the earlier period see Alan Peacock, "The 'Output' of the London Orchestras, 1966–75," *Musical Times* (August 1967). For the later period see Alan Peacock, Eddie Shoesmith, and Geoffrey Millner, *Inflation and the Performed Arts* (London: Arts Council of Great Britain, 1983).

8. This point is further demonstrated by the problem facing the British Broadcasting Corporation in 1980 when, as an economy measure, it sought to reduce the amount of broadcast time devoted to live orchestral music and to substitute more recorded music. It could not reduce the *size* of "in-house" orchestras to meet this condition, given no radical perceived change in the demand for the standard orchestral repertoire. The BBC therefore sought, against very strong union opposition, to reduce the *number* of "in-house" regional orchestras.

9. The author attended a splended concert by the English Concert in 1979 that included baroque music requiring original woodwind and brass as well as harpsichord and strings. In 1980 he attended an equally well attended and appreciated concert in which the repertoire had been so chosen that only harpsichord and strings were needed! The concert master confirmed that labor shedding had been necessary as a cost-cutting device.

10. The well-known experimental Traverse Theatre in Edinburgh cut the average size of the cast from 8.1 to 4.3 players between the 1975–76 and 1980–81 seasons.

11. Cf. Gary S. Becker, *The Economic Approach to Human Behavior* (Chicago, 1976), chap. 7 (with Robert T. Michael): "On the New Theory of Consumer Behavior."

12. Karl Marx wrote in typical fashion in 1876 about the mass move-

ment to "the Bayreuth fools' festival of the town musician Wagner." The first festival, however, resulted in a deficit of 120,000 marks. For details see John Chancellor, *Wagner* (London, 1978).

13. See my "Welfare Economics and Public Subsidies to the Arts," Manchester School, December 1969, reproduced in Mark Blaug, *The Economics of the Arts* (London, 1976). For a useful sumary of the issues see James L. Shanahan, "The Arts and Urban Development," in William S. Hendon et al., eds., *Economic Policy for the Arts* (Cambridge, Mass., 1980).

14. See, for example, the evidence of the Theatres' National Committee, which claims to represent the entire theater industry in the U.K. to the House of Commons Education, Science and Arts Committee, March 9, 1981.

15. Tibor Scitovsky, "What's Wrong with the Arts Is What's Wrong with Society," *American Economic Review* (May 1972), pp. 62–69.

16. As the vice-chancellor (president) of the first university independent of government finance and offering its own degrees founded in the U.K. this century, I speak with some feeling about the barriers to entry facing new entrants to the world of culture! They have to build up a loyal following of subscribers. We have at present only three "crops" of alumni who have to make their way in the world before they are both able and willing to help us!

17. A splendid parody of the more extreme position of the creative artist is found in Woody Allen's "If the Impressionists Had Been Dentists." A dentist called Vincent writes to Theo: "Mrs. Sol Schwimmer is suing me because I made her bridge as I felt it and not to fit her ridiculous mouth! That's right! I can't work to order like a common tradesman! I decided her bridge should be enormous and billowing, with wild, explosive teeth flaring up in every direction like fire! Now she is upset because it won't fit her mouth! She is so bourgeois and stupid, I want to smash her! I tried forcing her false plate in but it sticks out like a star burst chandelier. Still, I find it beautiful. She claims she can't chew! What do I care whether she can chew or not!" (From Woody Allen, *Without Feathers* [New York: Random House, 1975].)

CHAPTER 10

Availability of referenced source material: The Research Division Reports referenced on the tables and figures as the data source may be

obtained from the Publishing Center for Cultural Resources, 625 Broadway, New York, NY 10012. Cost and ordering information is available from the Publishing Center.

1. The appropriation for FY 1981 was neither cut back nor increased. It has been cut in subsequent years.

Chapter 12

1. Estimates made on the basis of receipts and ticket prices for various cities reported in *Variety* by George Wachtell of the League of New York Theaters and Producers, Inc. Data obtained after this chapter was written indicate that in 1981 audiences of both the Broadway theater and the road declined somewhat from their 1980 levels.

2. The orchestra sample varies from year to year as the number of orchestras that report changes. In 1973–74 the sample included 31 major orchestras and 66 metropolitan orchestras; in 1979–80 it included 32 majors, 28 regionals (an intermediate category set up in 1975–76), and 65 metropolitans. The data are adjusted at ASOL to correct for the small number of orchestras that fail to provide data in any given year. (Information is always provided by all the majors, some 95 percent of the regionals, and 70 to 80 percent of the metropolitans.) In 1979–80 the three categories were defined as follows. A major orchestra must have had an income of no less than $2 million in 1978–79 and $2.25 million in 1979–80. A regional's income must have been at least $500,000 in 1978–79 and $600,000 in 1979–80. That of a metropolitan must have been $100,000 and $150,000 in the respective years. For all our information we are indebted to Lisa Gonzales, ASOL's director of research and reference, to whom we are all also indebted for her impeccable statistical work.

3. William J. Baumol and William G. Bowen, *Performing Arts—The Economic Dilemma* (New York: The Twentieth Century Fund, 1966).

4. Ibid., p. 190.

5. *Theatre Facts 81*, p. 14.

6. The situation is changing rapidly. In the last few years, real ticket price has risen rapidly so that by the 1981–82 season, the top price in constant dollars for a seat at a musical was almost as high as it was in the very early 1930s, and the price of a seat to a straight play was the highest ever. Probably, given the consequences of the cost disease, the ratio of

ticket prices to costs is nevertheless still well behind what it was in earlier decades.

7. The 1981 figures show a continued real increase in foundation grants to the arts and humanities of about 10 percent above the previous year.

8. In 1981, state arts council appropriations again increased slightly, even in constant dollars.

9. A cut in federal funding was averted in 1981, but the actual amount apropriated in 1982 was only $143 million as compared with $158.8 million the year before, and the 1983 figure will probably be even lower.

10. R. V. Burkhauser and Malcolm Getz, "What Federal Subsidies Subsidize: The Case of Symphony Orchestras," working paper No. 81-WA10, October 1981, Vanderbilt University. Quoted by permission of the authors.

11. Ibid., p. 17.

12. Theatre Communications Group, Inc., *Theatre Facts* (annual statistical summary).

13. See William B. Conley, "NEA Cuts and the Non-Profit Theatre," Department of Economics, Princeton University, December 1981 (unpublished).

14. As reported in the *New York Times*, July 2, 1981, "Museums Options" by M. P. Clark. A correspondingly pessimistic projection appears in a 1982 study for the Urban Institute prepared by Lester M. Salamon and Alan J. Abramson.

APPENDIX

1. Early in 1982 the Musicians' Union of Las Vegas, Local No. 369, had some 1,300 members. Of these, 750 were employed at least part-time as musicians; of the remaining 550, about 130 were employed in nonmusicians' jobs (at wage rates below those for musicians), and the other 420 were unemployed. The resulting unemployment rate for musicians in the Las Vegas market was 32 percent, with another 10 percent clearly underemployed. The figures cited here were given to me by Mark Tulli Massagli, president of the Musicians' Union of Las Vegas, Local No. 369, in a conversation in February 1982.

2. The doctoral dissertation of Chien Chiao sets forth a model for the study of the Navaho singer as a cultural transmitter and contrasts the Navaho practices with traditional Chinese methods. See Chien Chiao,

"The Continuation of Tradition: Navaho and Chinese Models," Ph.D. diss., Cornell University, 1969.

3. Richard Meltzer, *The Aesthetics of Rock* (New York: Something Else Press, 1970), contains much behavioral material that is of more than passing interest to the serious scholar.

4. It is perhaps the differences rather than the similarities between music and written and spoken language that are most important to linguistics. See the chapter entitled "Synaesthesia" in Terence McLaughlin, *Music and Communication* (New York: St. Martin's Press, 1970), pp. 62–78.

5. William J. Baumol and William G. Bowen, *Performing Arts—The Economic Dilemma* (New York: The Twentieth Century Fund, 1966).